Alice's Adventures

ALICE HAWKINS

ALICE'S ADVENTURES

by

ALICE HAWKINS

With contributions by Katie Grand, Mark Haywood,
John C. Jay, Frith Kerr and Nick Knight.

with 230 illustrations

Thames & Hudson

For my dad

First published in the United Kingdom
in 2017 by Thames & Hudson Ltd,
181A High Holborn, London WC1V 7QX

Designed by
Studio Frith

British Library Cataloguing-in-Publication Data
A catalogue record for this book
is available from the British Library

ISBN 978-0-500-29290-7

Printed and bound in China by Reliance
Printing (Shenzhen) Co. Ltd

To find out about all our publications, please visit
www.thamesandhudson.com. There you can
subscribe to our e-newsletter, browse or download
our current catalogue, and buy any titles that are in print.

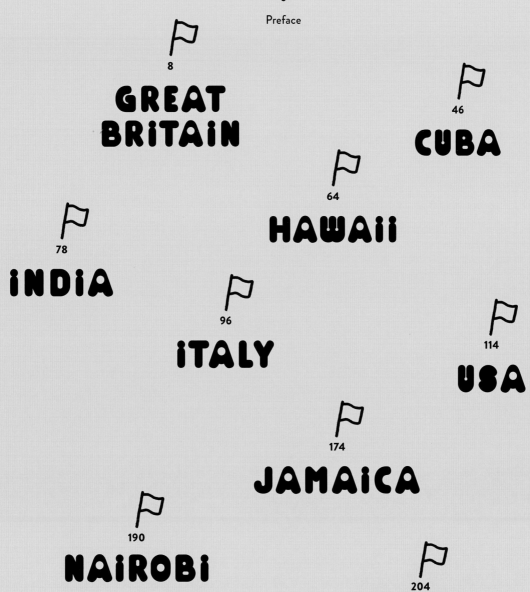

Preface

I remember excitedly explaining to my mum my plan to drive around Texas for three weeks with my camera, another girl and twelve suitcases of clothes. She was worried that we'd get lost, kidnapped or murdered. I tried to convince her that we'd be fine; that I'd heard Texans are very friendly and anyway, Dad knew an old lady we could visit in a town called Brownwood.

I wasn't sure of anything, except that this experience would be an adventure and that really, getting lost was the point. I prayed that we'd get the pictures of the characters and places I envisaged, and that all the clothes would fit.

The moment I stepped off the plane in Dallas, I had the unreal feeling of being on a movie set. My first thought was of cowboys, truck drivers and trailer-park beauties. That very night I met Cletus, the bellman at a hotel we'd found. He was an ageless, beautiful man who seemed kind. I decided then and there that he should be the first person I photographed. We later hugged as we said goodbye, and I can still hear the twang in his parting words: 'Y'all make me feel like a Sunday.'

I love making friends with strangers. Photographing a stranger can be a bonding experience. In this way I form lifelong memories and friendships, and it gives me a thrill to travel and to cast as I go. Many flights, ideas and random moments have led me to scenes that dreams are made of. While most of my photographs are within the realm of fashion and art, I also see them as a personal record of chance encounters with people from other worlds and ways of life. Sometimes I make a friend, and a photograph follows; other times I take a photograph and make a friend.

Character is paramount in my work, and I'm attracted to people from all walks of life. I want to capture an element of truth in my subjects and their personal environments. This is the approach that works best for my pictures, amid the challenges and logistics of shooting on the road; it doesn't make sense to do it any other way. Luck always plays a part, so while I prepare as much as possible in advance, I keep myself open to every possibility.

I like to travel to far-flung places that I've never been to. Like most people, I find that my consciousness is heightened and I come alive in a way that I never could in the familiar environment of home. I want people with different views from diverse backgrounds to trust me so that I can capture and convey something of their reality and aspirations. It doesn't always go as smoothly as I would like, but that only makes it more exciting when a connection is made with someone and a kind of mutual trust quickly builds up. Whenever I drive away from a subject or fly home from a new place, I feel like my life has been enriched and I look forward to my next adventure.

GREAT BRITAIN

Robert & his horse...

Tiger and friends - London
Cadene

Charlie... chelsea. 2004.
- london
Nov/dec

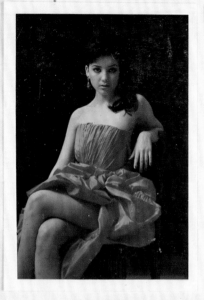

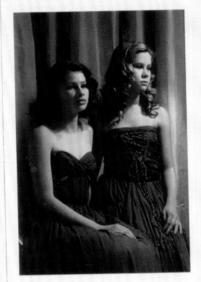

Miss Daisy Lowe - 16 years old.
 Dec 04 · London

Jazzy London. 2004.

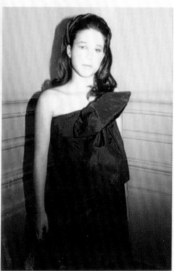

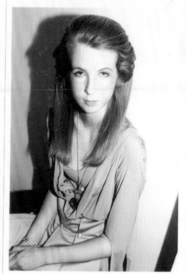

Cleo.

Robert & Tom

~~India & Tilly~~ Standing.
Mums shop in London.

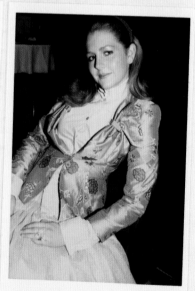

Daisy @ RHS

Definates to go into new printed Book. Teenagers story Pop magazine

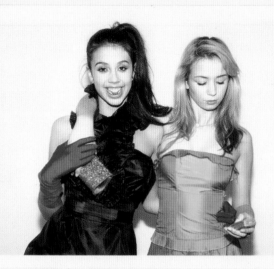

Jazzy texting.

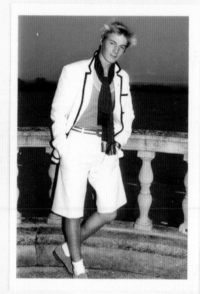

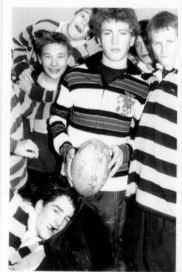

Charles @ RHS.

Christopher @ RHS.

MissColchester
4781
4819

JJ - 4435
4?1-1

3?

Bonny - 39?

Good Bags
Give to JUSTINE → Bex - 4506

Bonnie - 4115 - handles - 4
4075 40

Whitney - 3?7 3764

JADE - 4371 - 4?

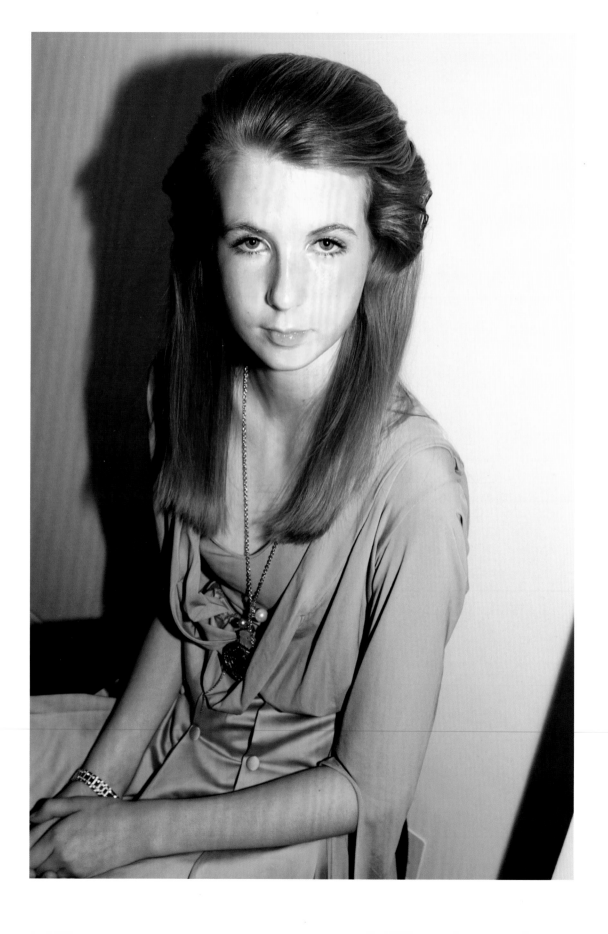

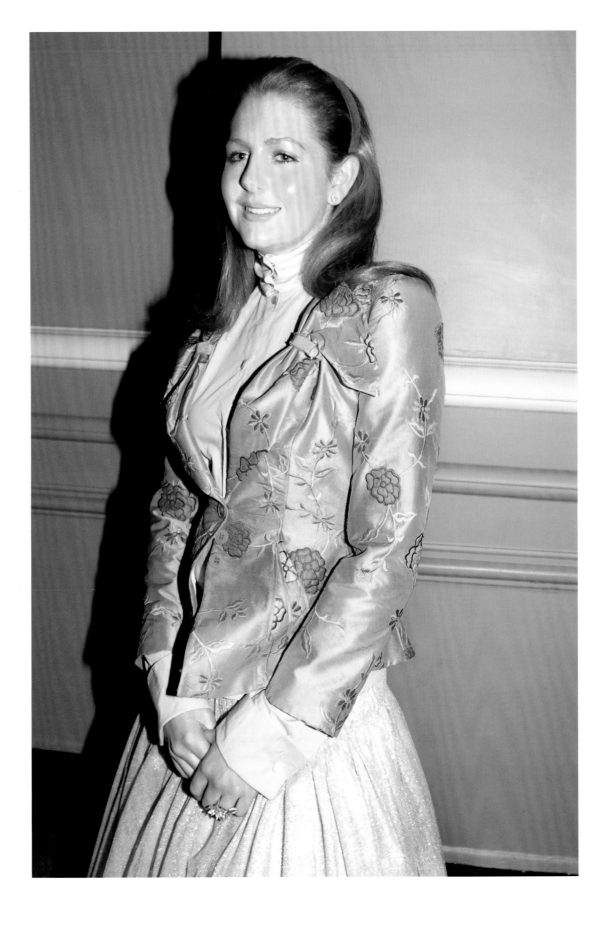

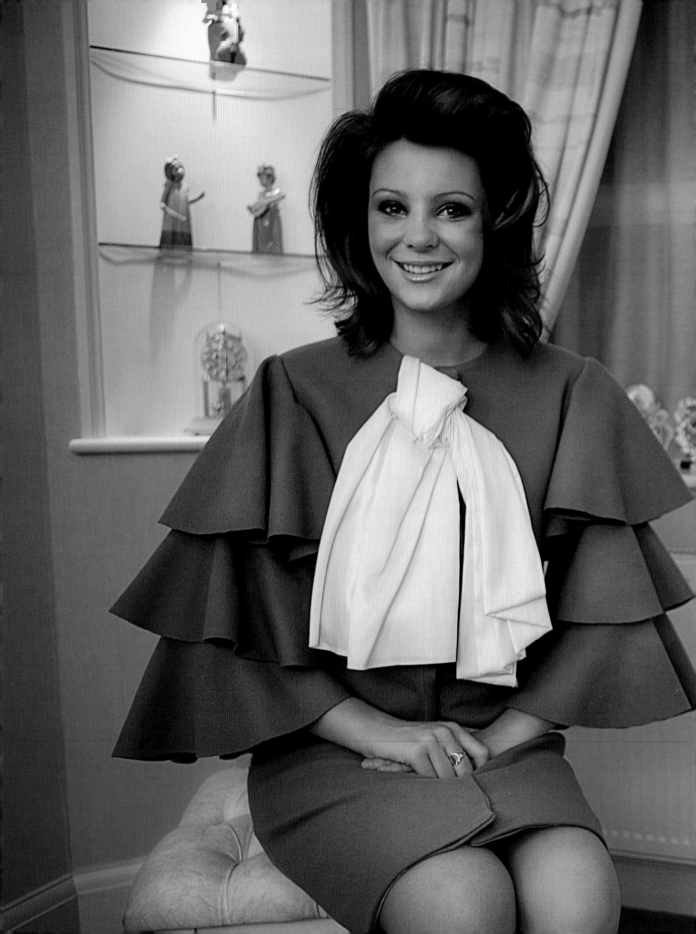

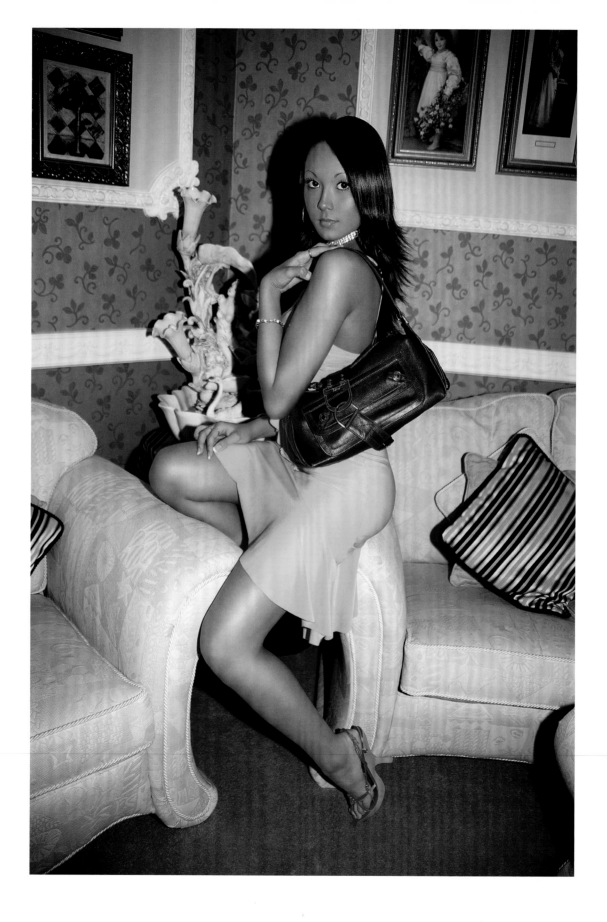

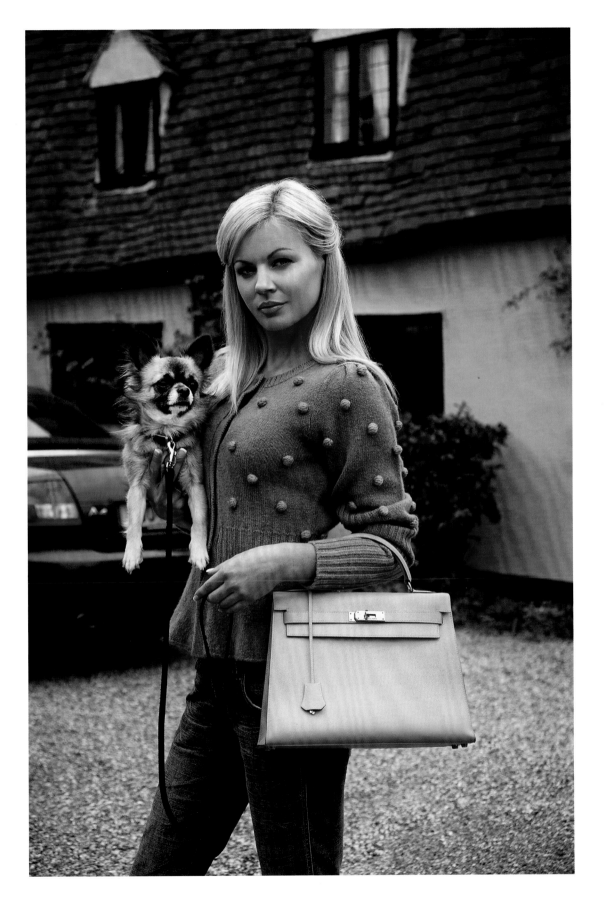

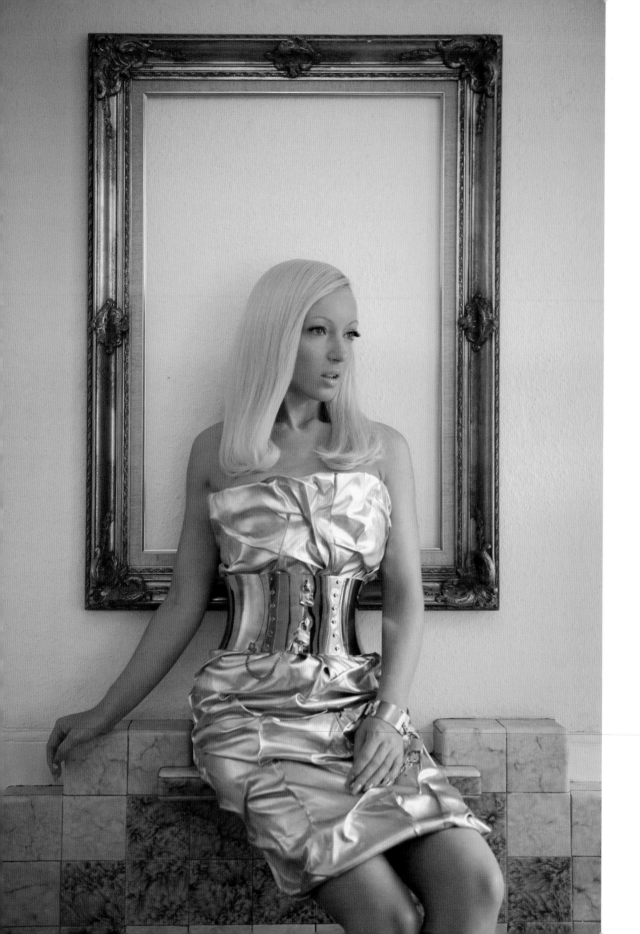

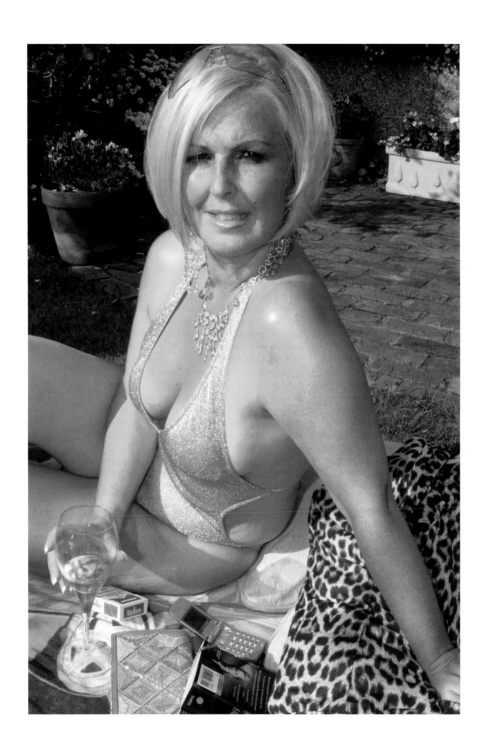

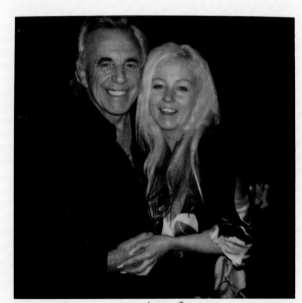

Me & Stringy -Stringfellows March 2007.

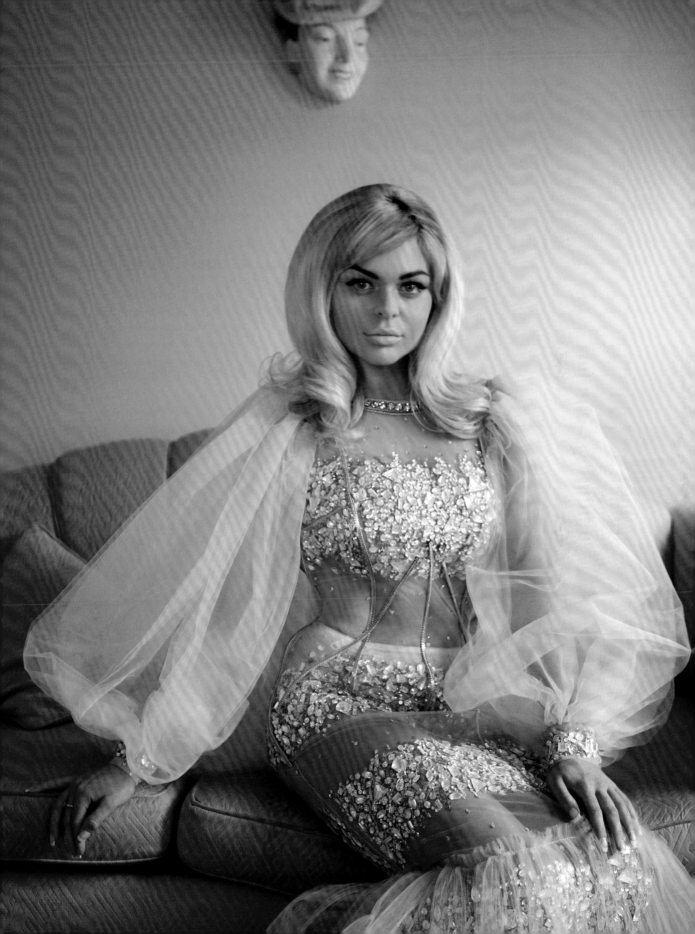

2009 dear Alice — Feb 12th
love Sarah
The Duchess of York

kimi , Queens guard + me
(Princess) POP (The Queen)
Anne) magazine HRH

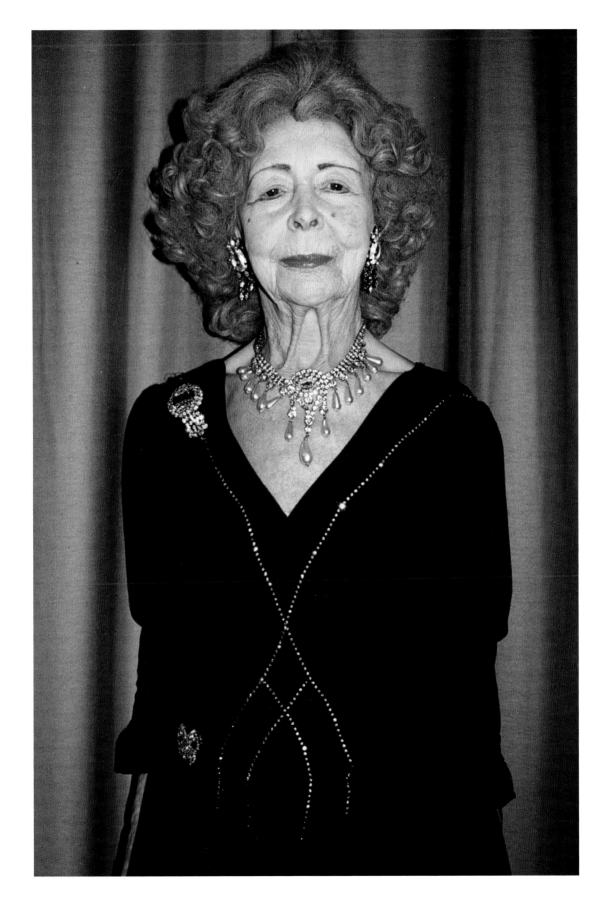

KATE DARLING

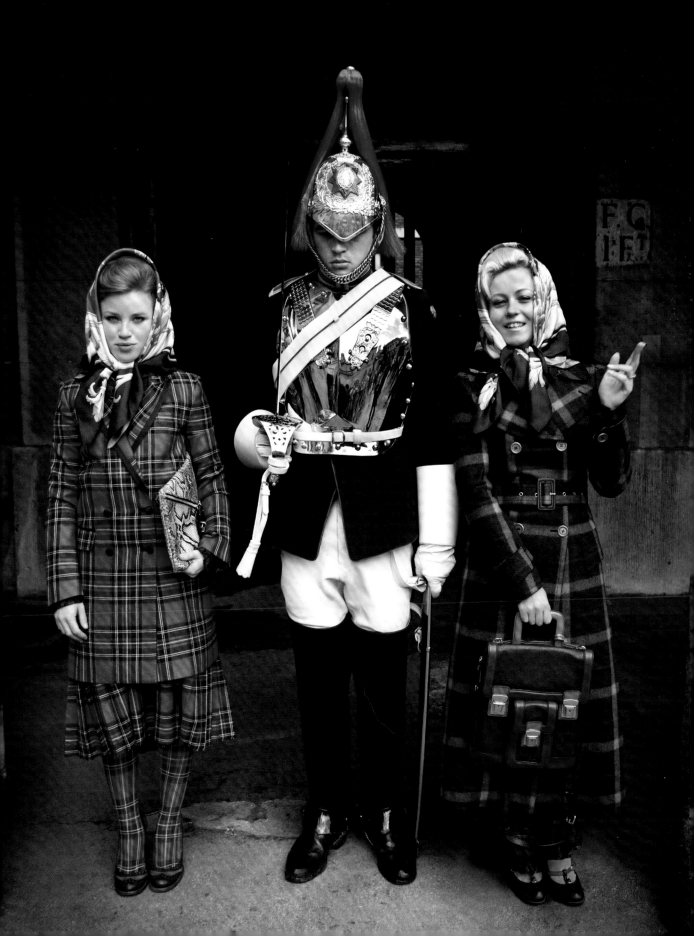

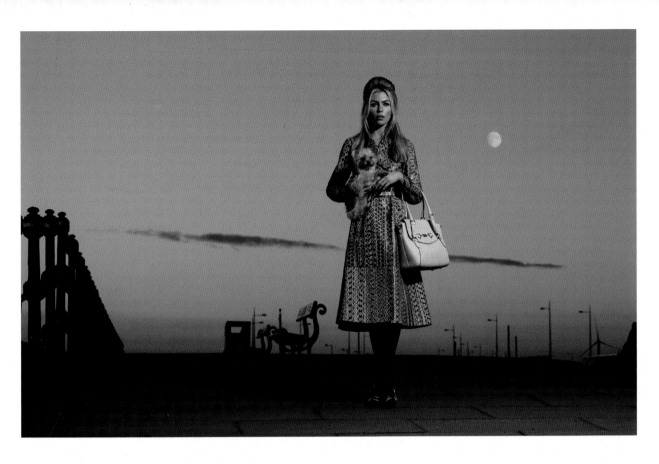

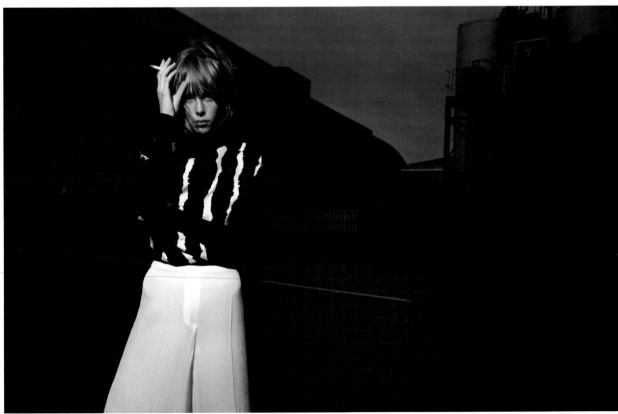

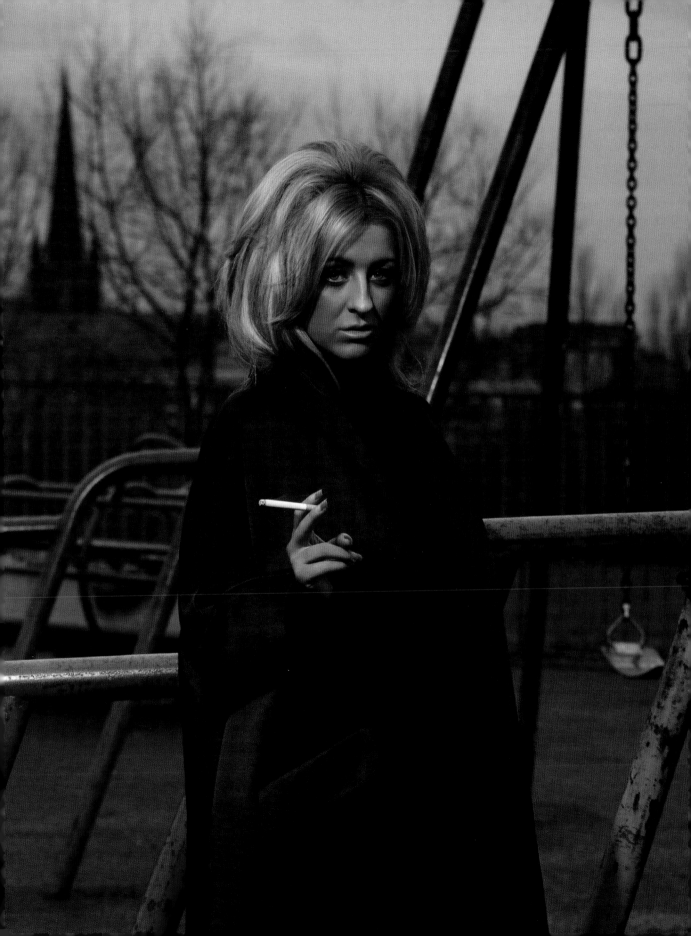

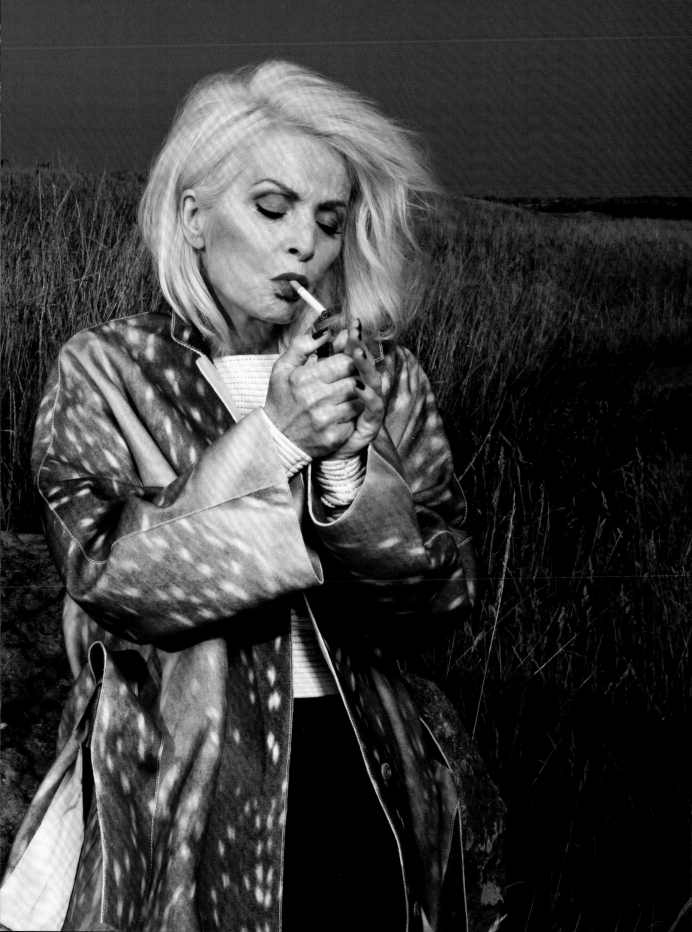

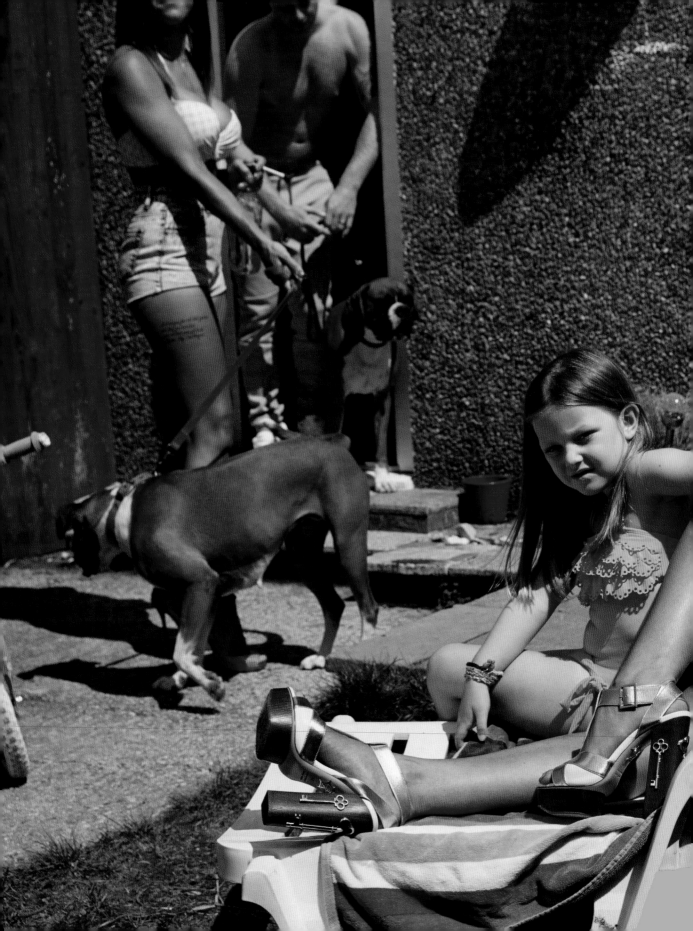

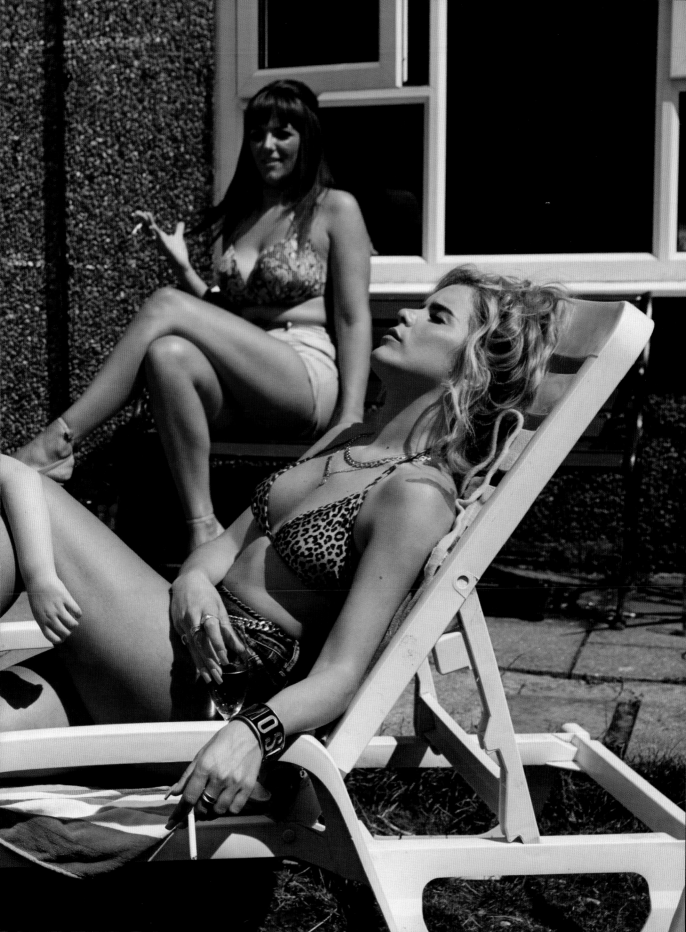

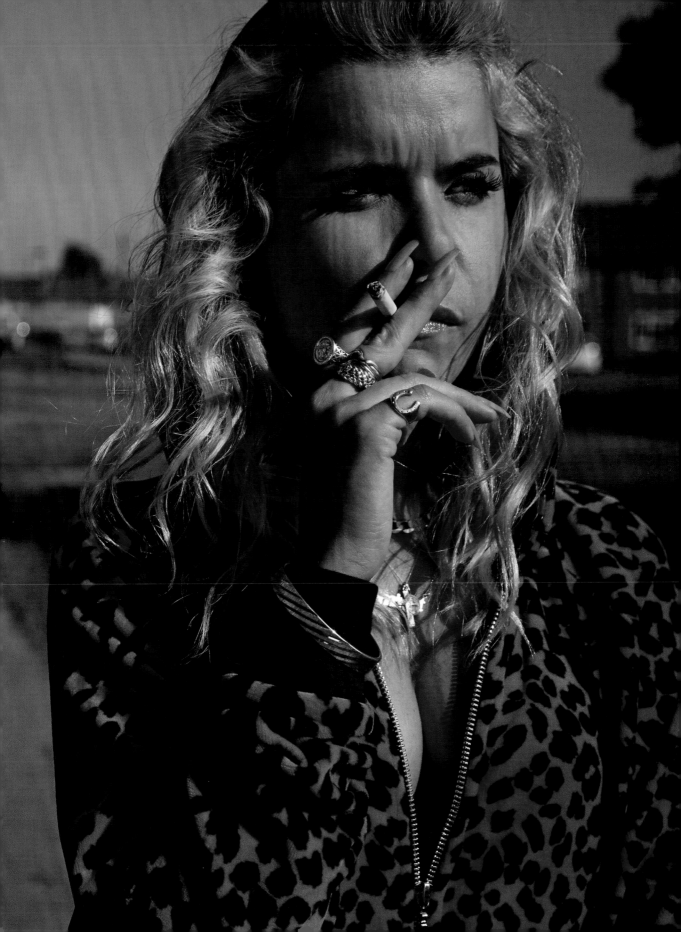

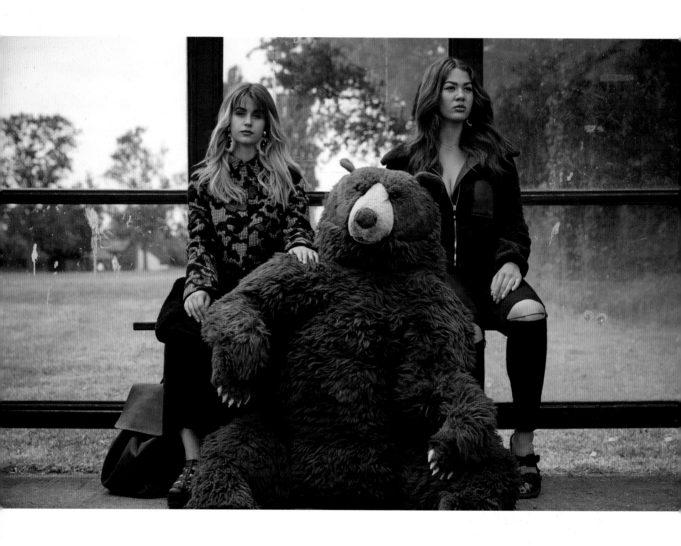

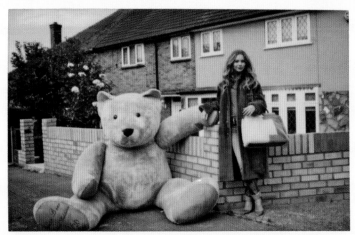

Paige + a really expensive massive
Bear in Romford . Essex . 2015

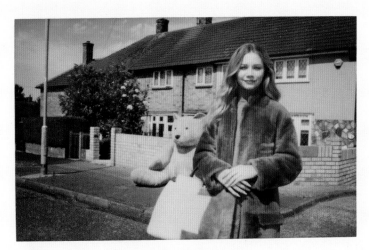

Paige . Romford .

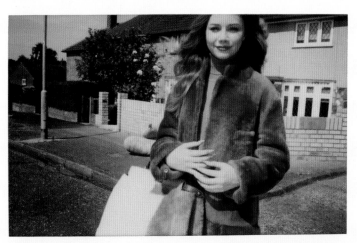

Paige . Romford . Essex . I've wanted to
♡ ♡ ♡ ♡ ♡ ♡ photograph Paige + her
sister Scarlett 4 eva !!

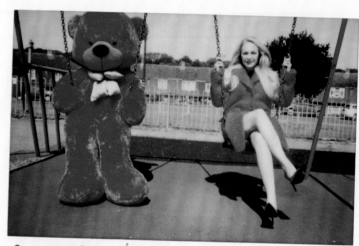

Sydney + Bear. Loughton. Essex
Garagemagazine 2015

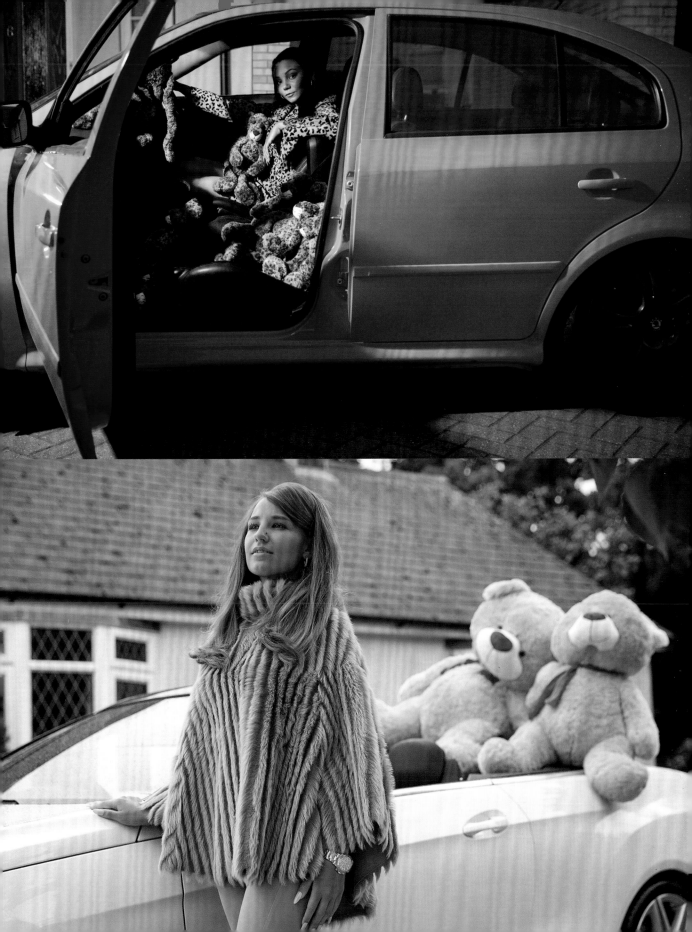

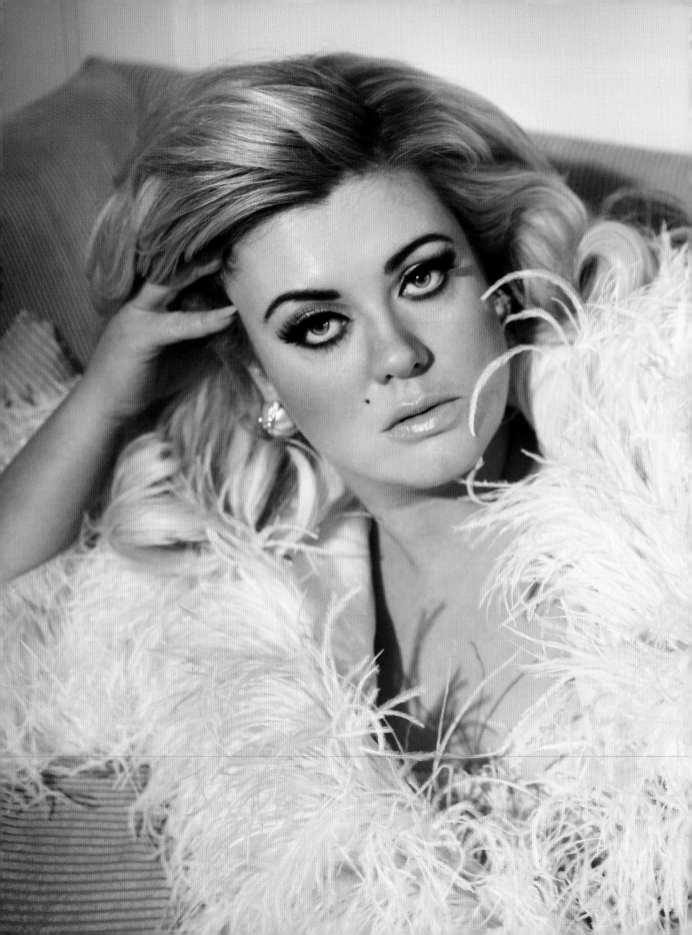

She calls me Frithybaby – nobody else does.

I met Alice when she was at art school; she threw a party as her degree show.

Her ideas have always been way ahead, flung into a suitcase, put on a plane.

She is an anthropologist for the modern age.

She can talk her way around the world, to anyone, anywhere.

Armed with wit and hair, she's unstoppable.

She's genuinely free in a world that wants to create boundaries and enforce categories.

She's a High-Gloss Adventurer.

A superhero on a mission to save the world from being boring.

She's Alice.

Frith Kerr

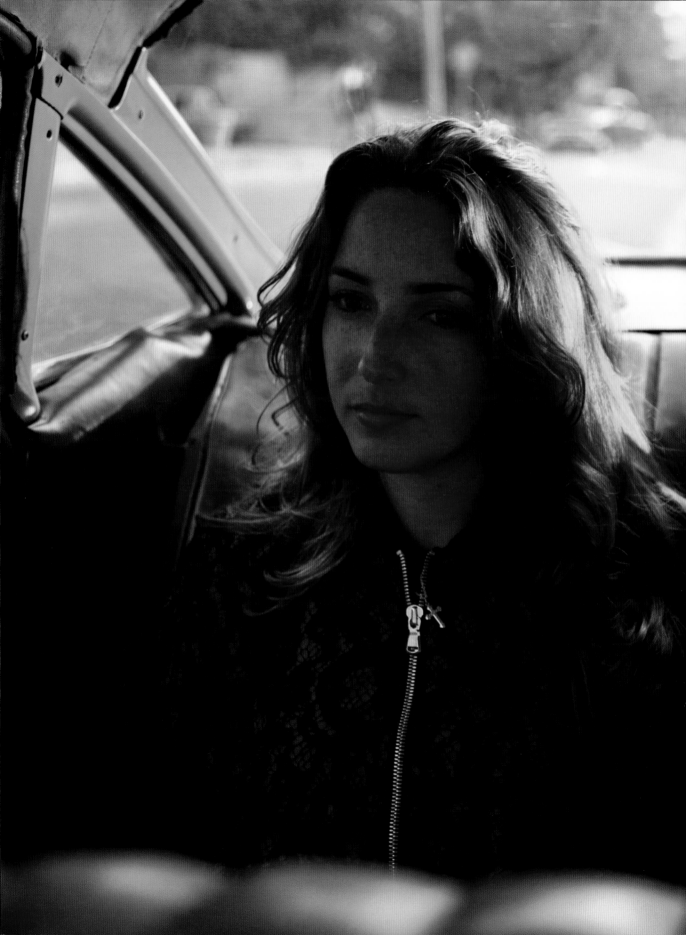

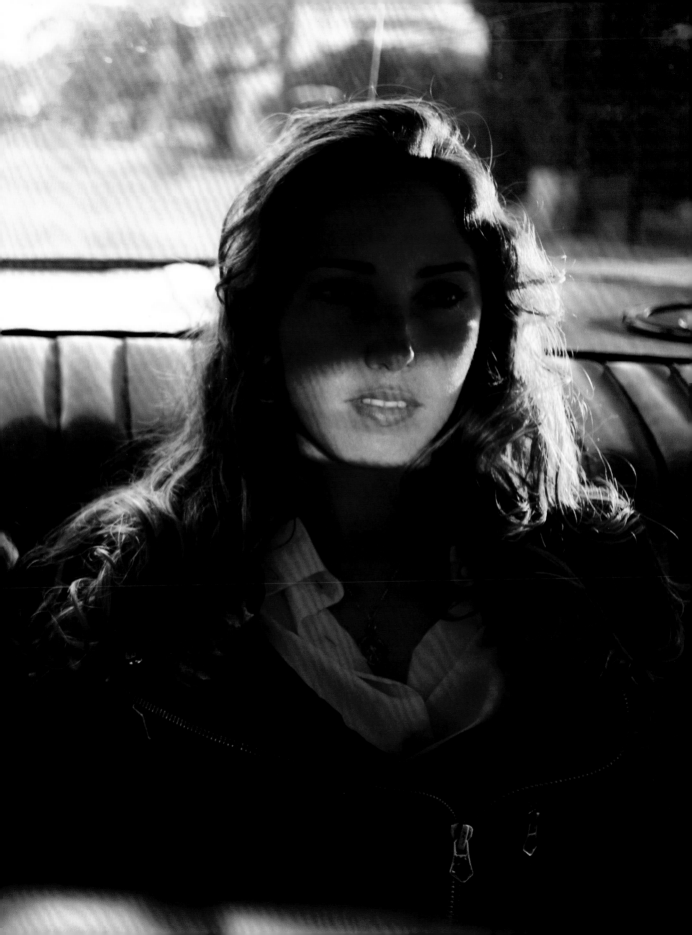

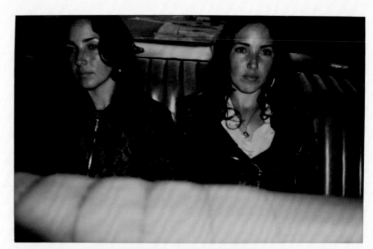

identical twins, Havana CUBA.
love mag Adrianne & Alejandro

♡ ♡ ♡ ♡

Joandy & Leysie, village nr Havana
FIRST SHOT! 1ST DAY Cuba 2012

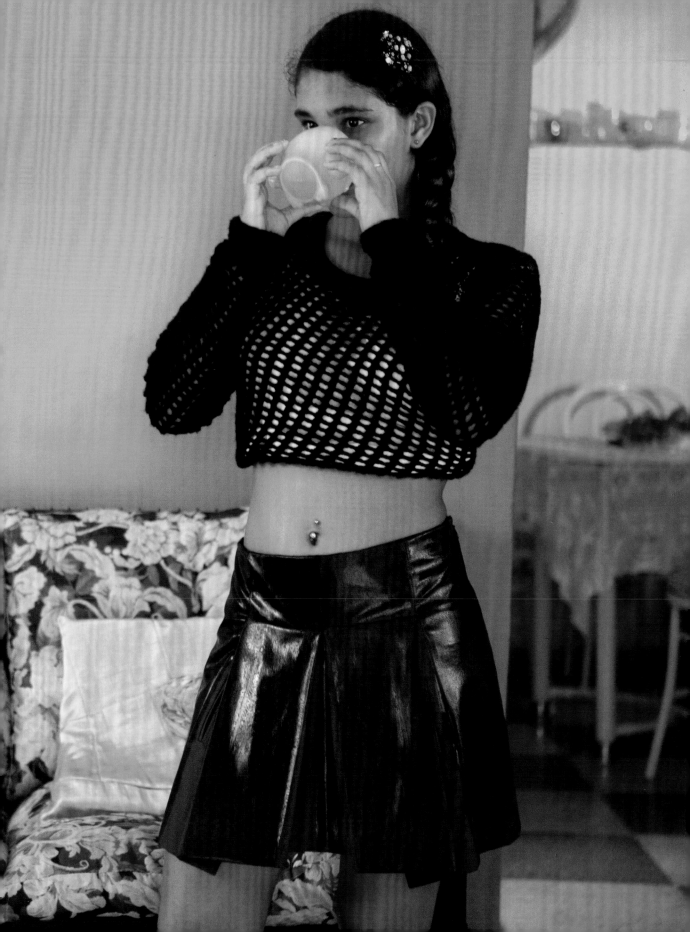

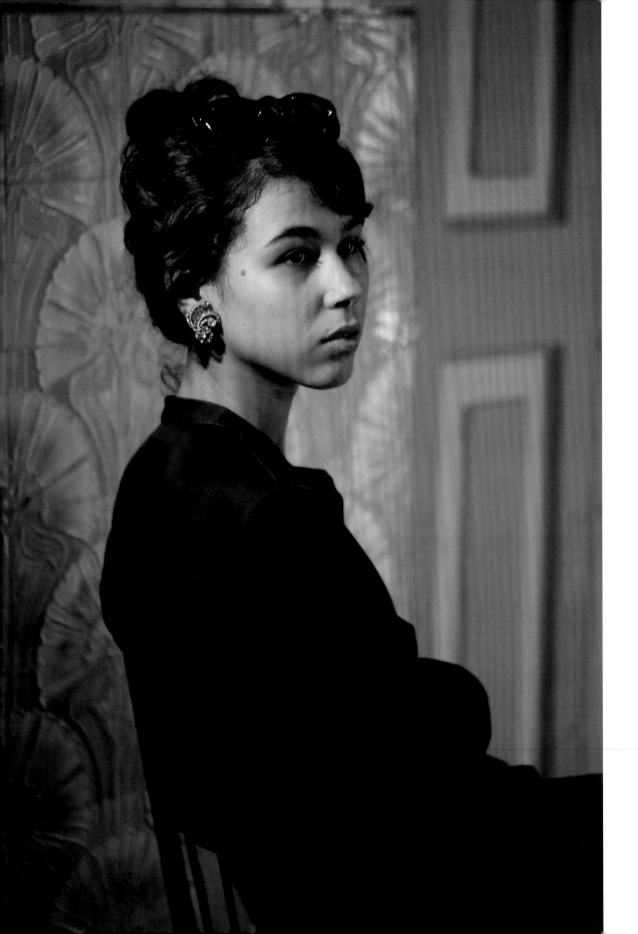

Elizabeth, Havana, 2012 Cuba Love
Our producers girlfriend ♡

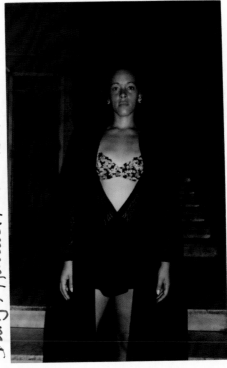

Willie, our 'other' producers girl crush ♡
Daily, Havana, Cuba 2012

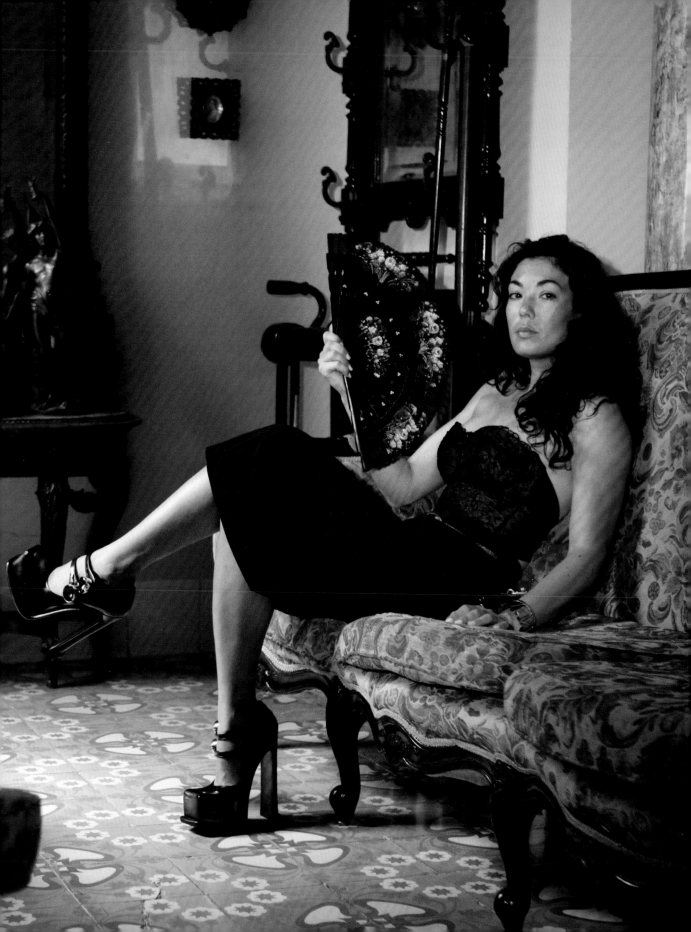

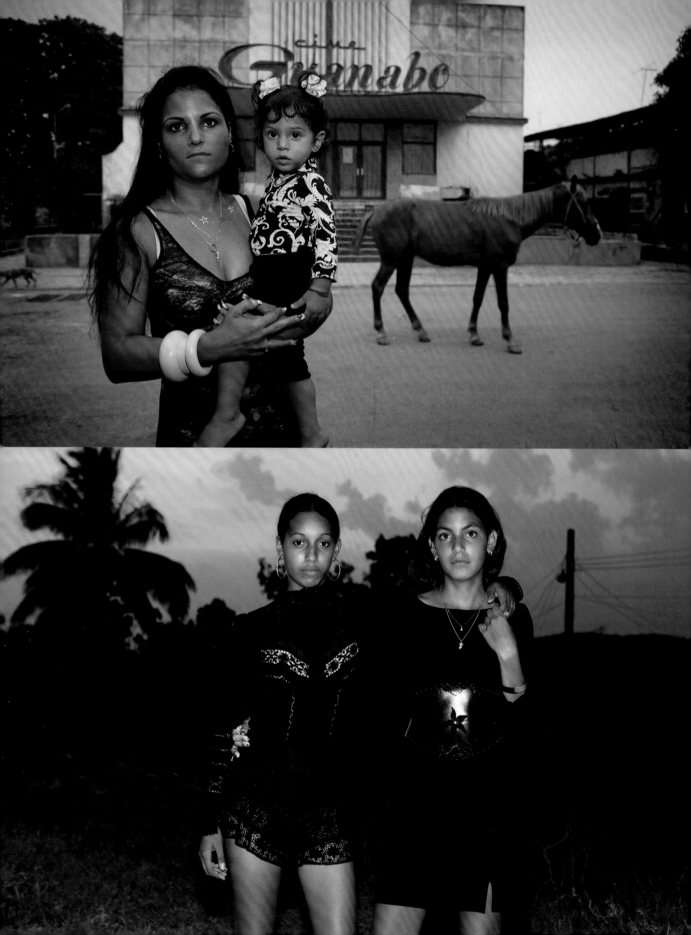

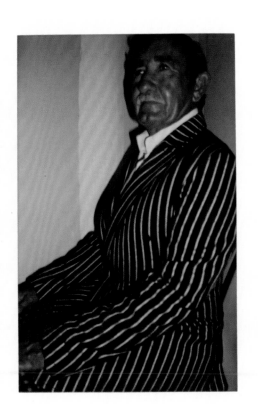

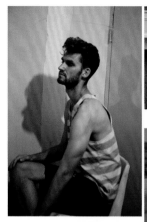
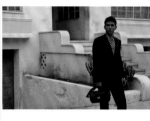

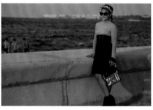
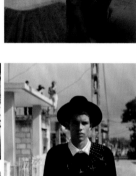
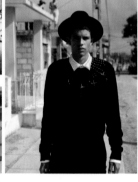
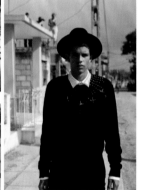
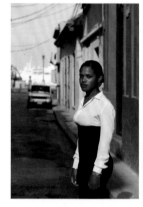
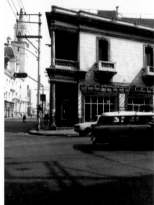
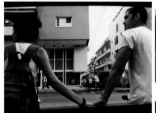

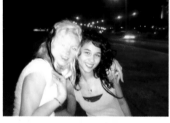
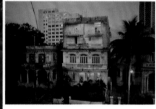
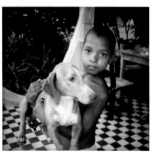
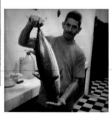
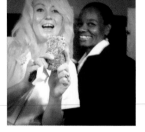
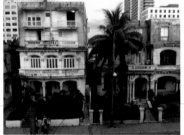

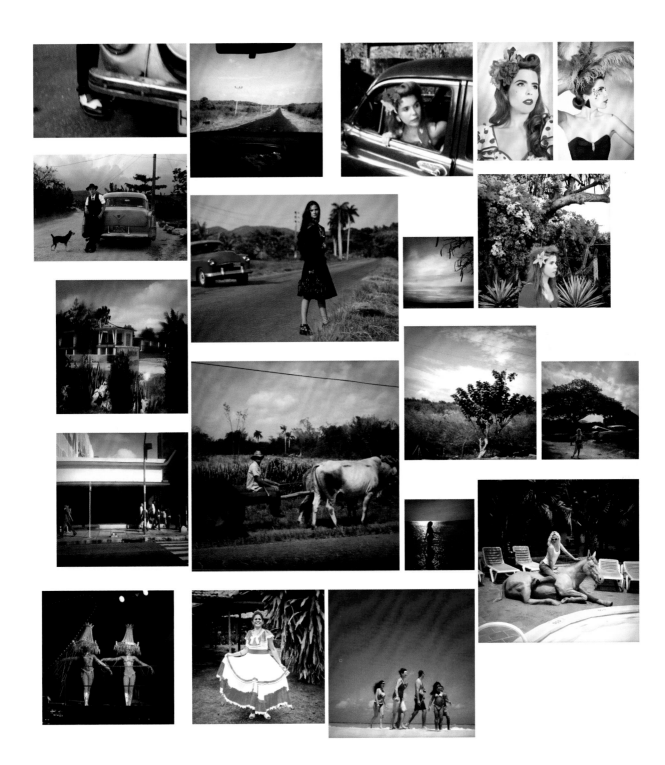

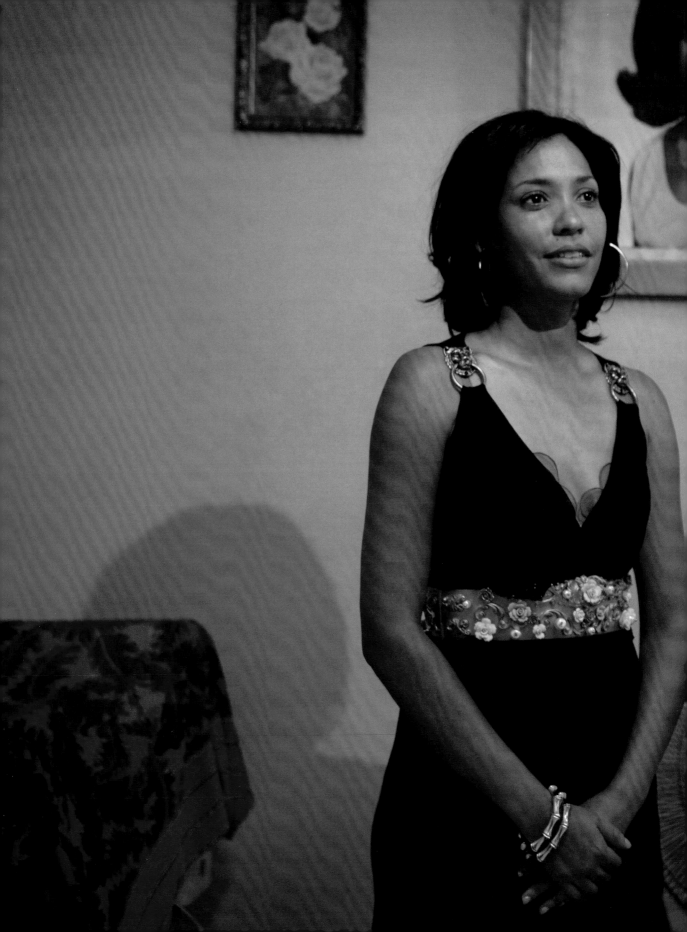

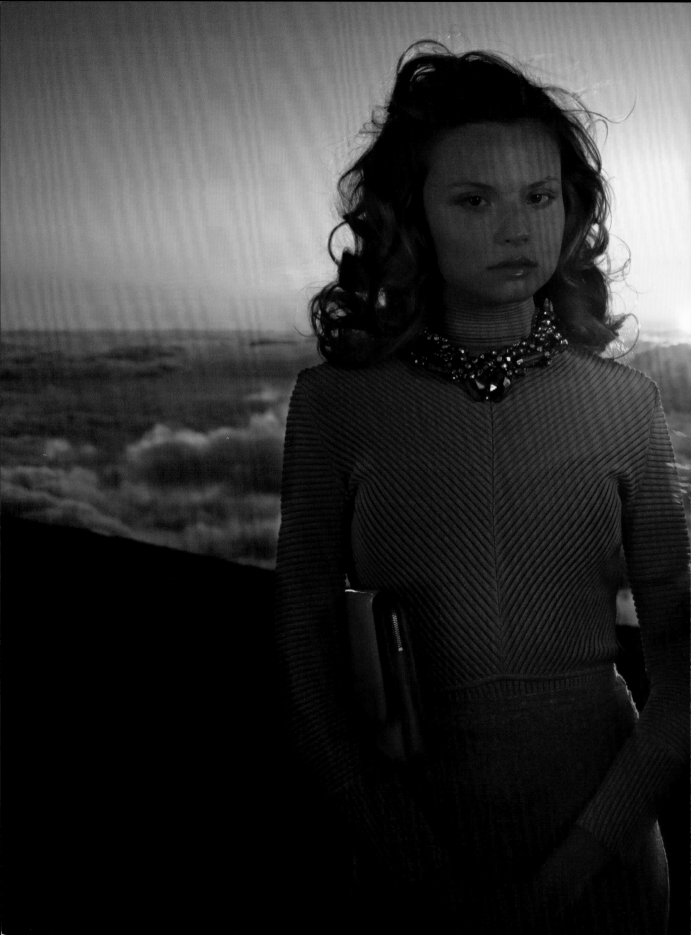

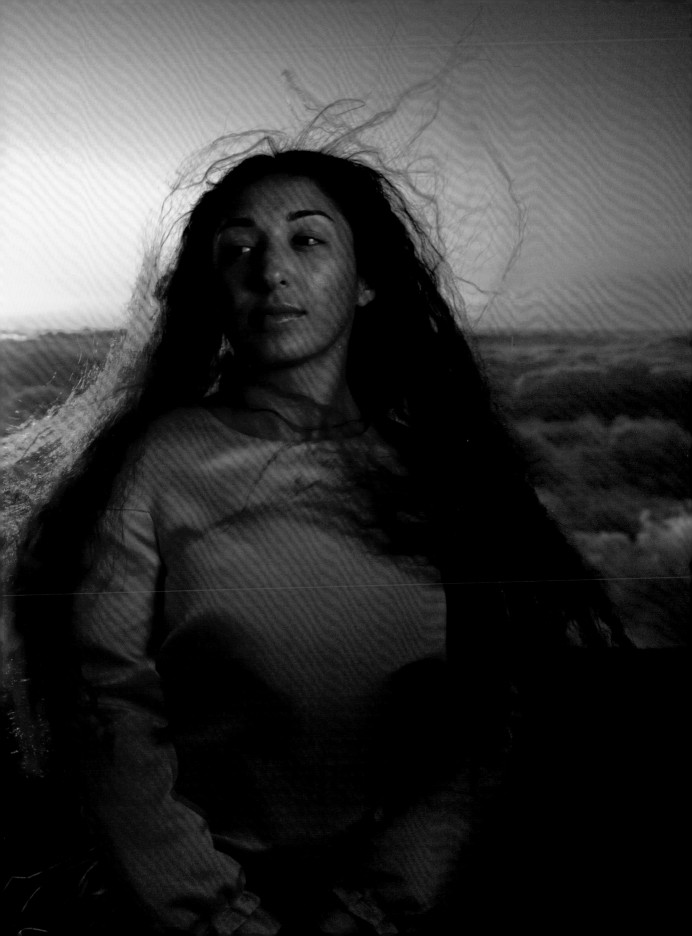

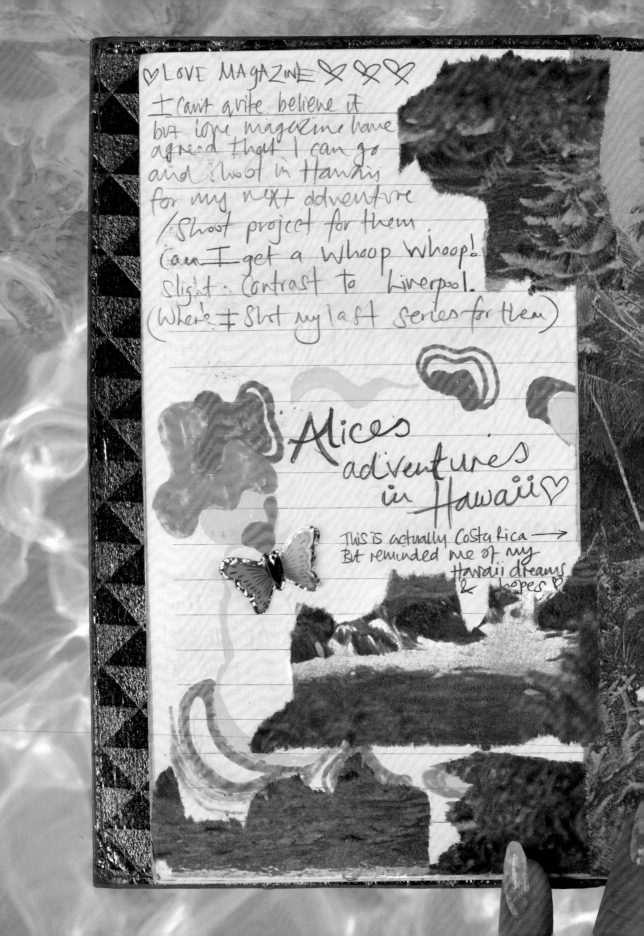

♡LOVE MAGAZINE ✗ ✗ ♡
I cant quite believe it
but love magazine have
agreed that I can go
and shoot in Hawaii
for my next adventure
/shoot project for them.
Can I get a whoop whoop!
Slight contrast to Liverpool.
(Where I shot my last series for them)

Alices
adventures
in Hawaii♡

This is actually Costa Rica →
But reminded me of my
Hawaii dreams
& hopes ♡

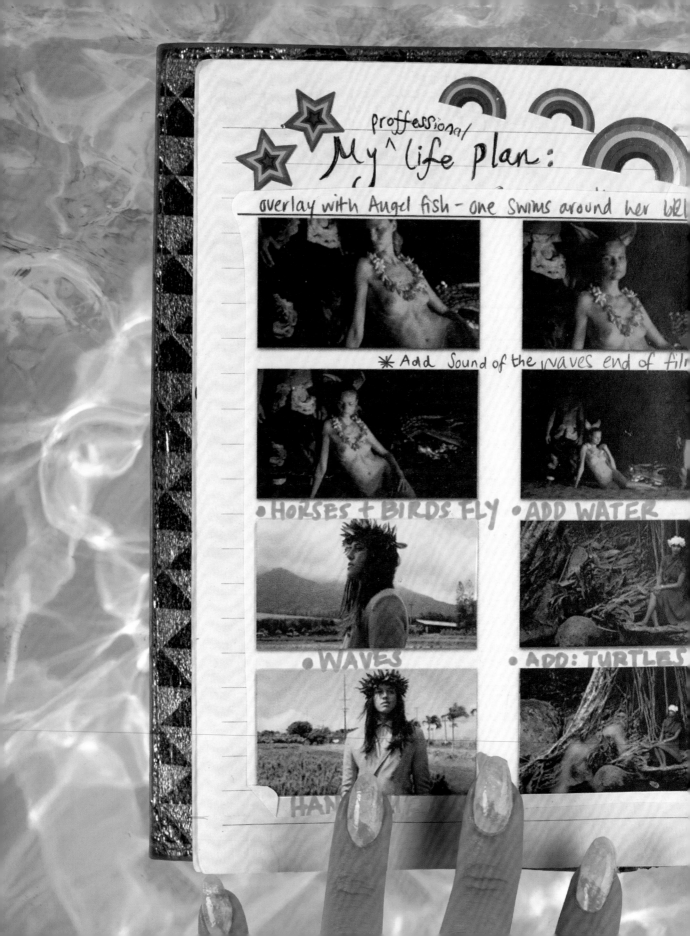

TROPICAL HOTEL
CARPET USE ♡♥

ton ♥♥

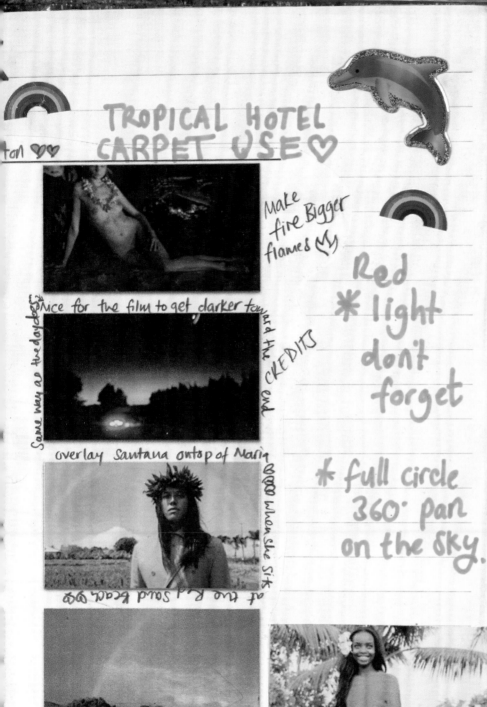

Make
fire Bigger
flames ♡

Nice for the film to get darker toward the end

Same way as the daydream

CREDITS

overlay Santana on top of Maria @@@@ when she sits

at the R. J Sand Beach @@@

Red
* light
don't
forget

* full circle
360° pan
on the sky.

Rainbows are So good ♡ ⌒ ♡ ⌒

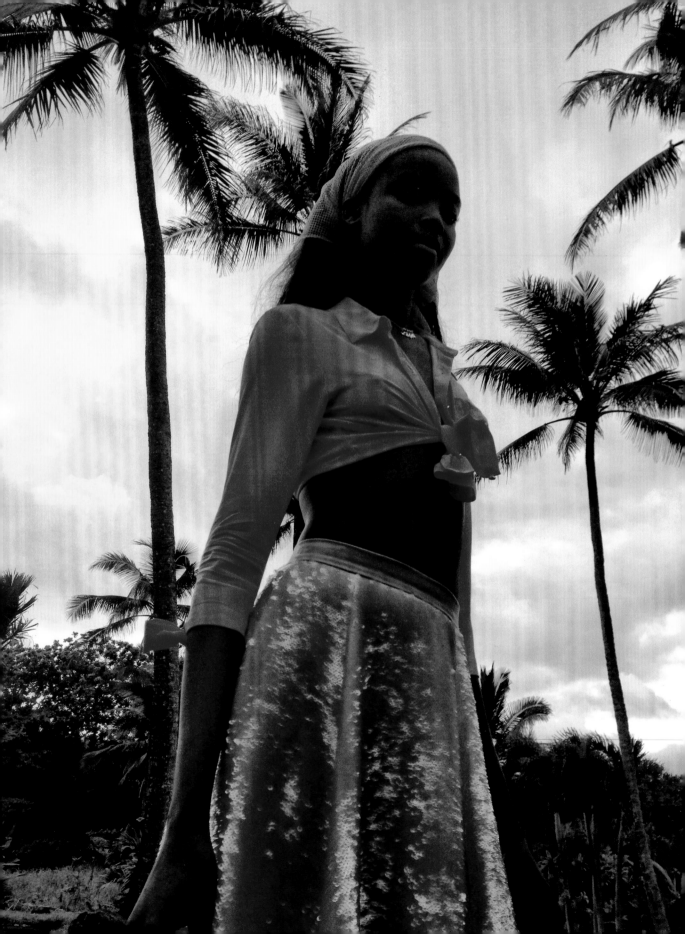

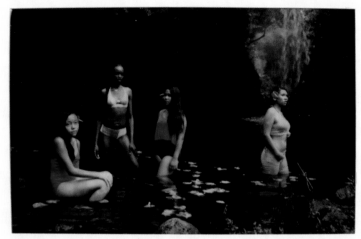

Maria + some local Island girls in the
waterfall at the end of their garden!

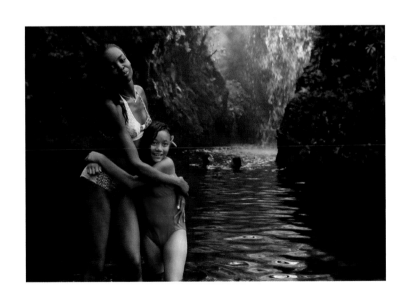

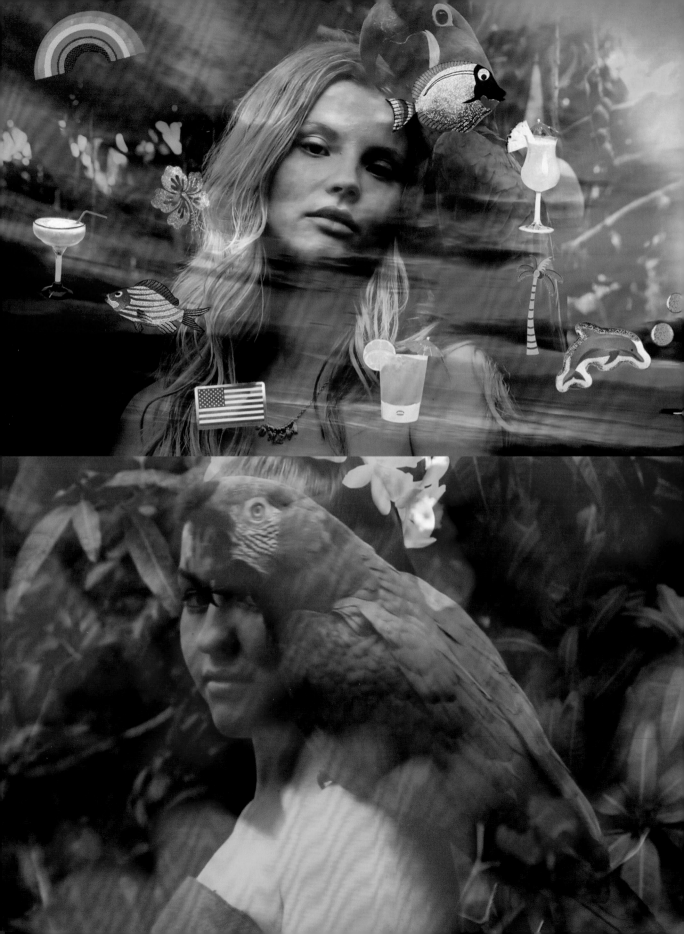

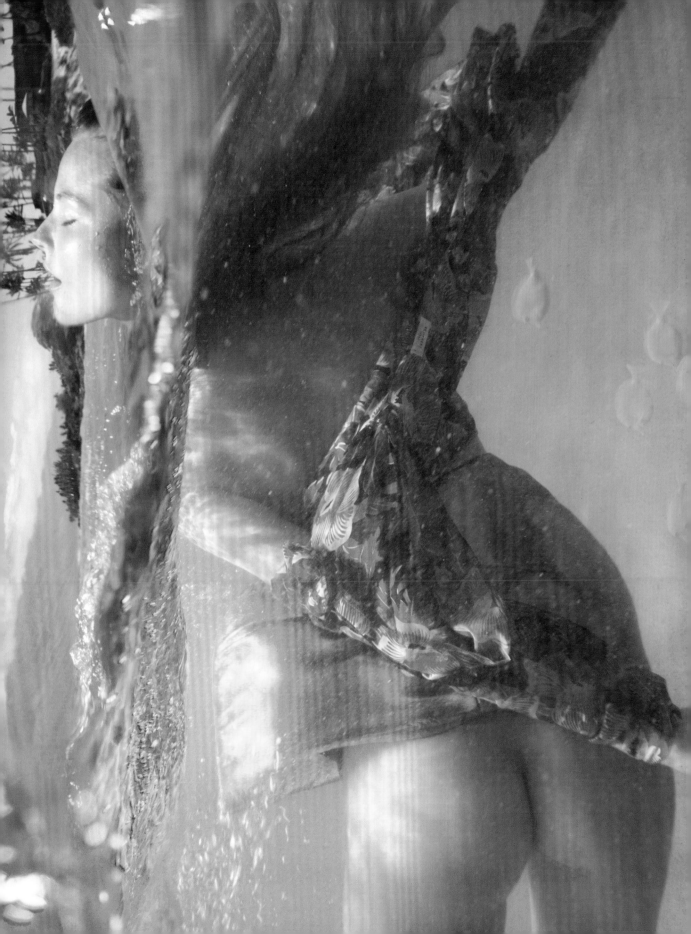

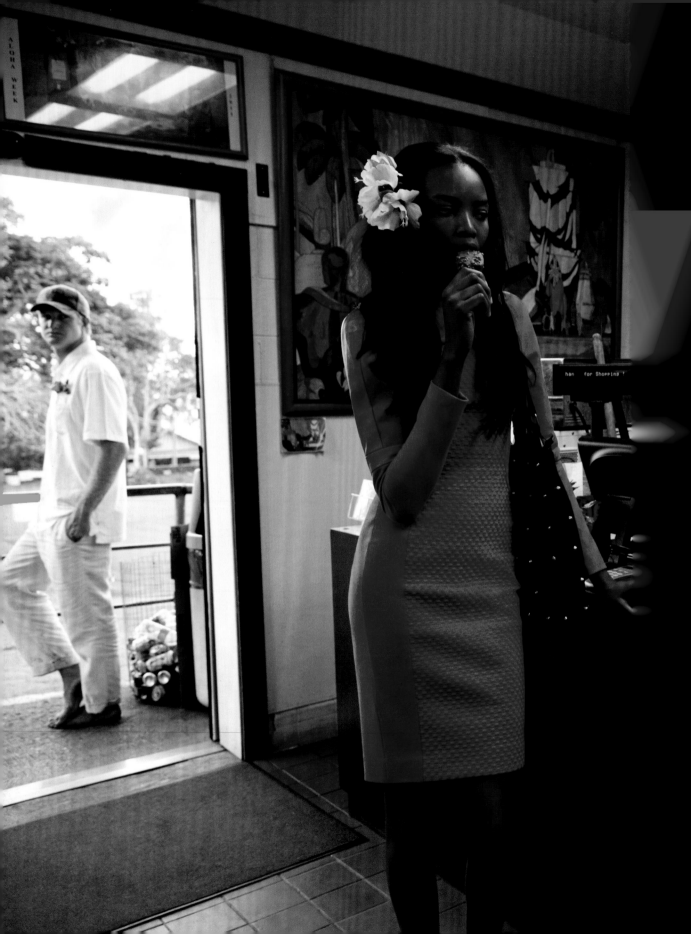

③ 21·08·

FACTORY GIR

credit :
Chole.

Met a ma
who owns
a huge facto
he said we
could come
along and
cast from
his staff.
R,
this man +
girl are so
beautiful.
BINGO! ✦

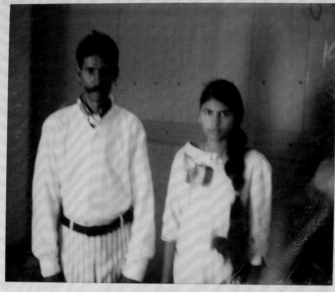

Mona Rajput

Indian
Artist Photographer :

NIKHIL SHAMSHER BHANDARI

www. NIKHILSHAMSHER. COM
www. IPW. ORG. IN
ALICe in Ind
2007

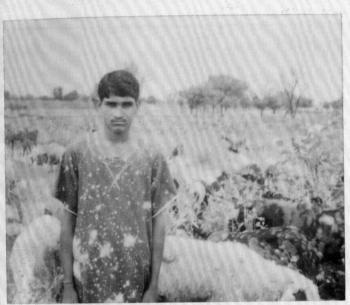

Goat farmer boy - Manohar Singh

GOAT BOY:

CREDIT: Diesel

97 98
99
100
122

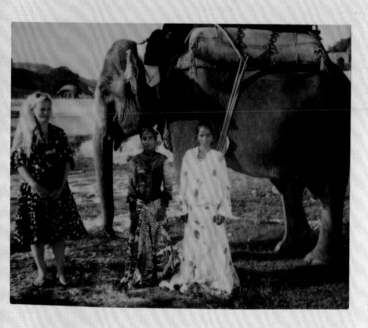

21·08·07 (1)
SNAKE
CHARMERS:
Brothers
Credits:
Jaipur.
Salvatore
ferragamo,

acquascutum
&
etro brooch.

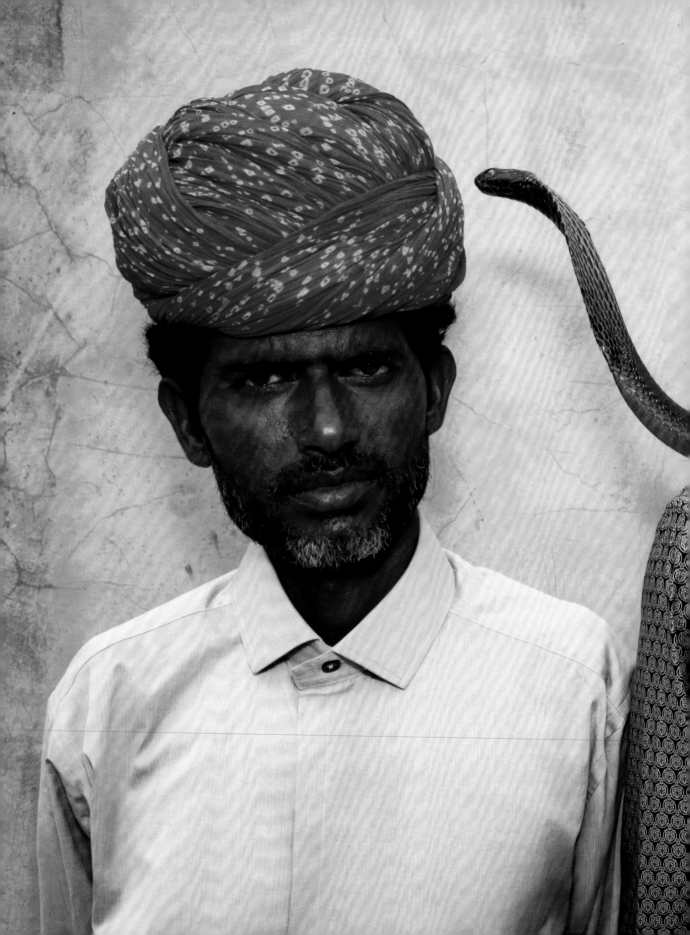

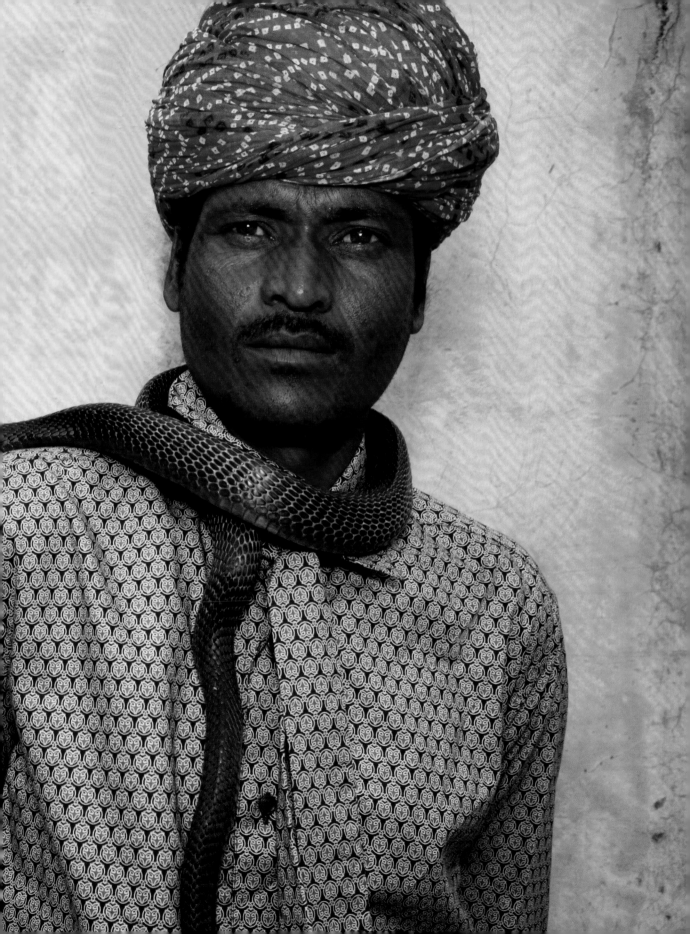

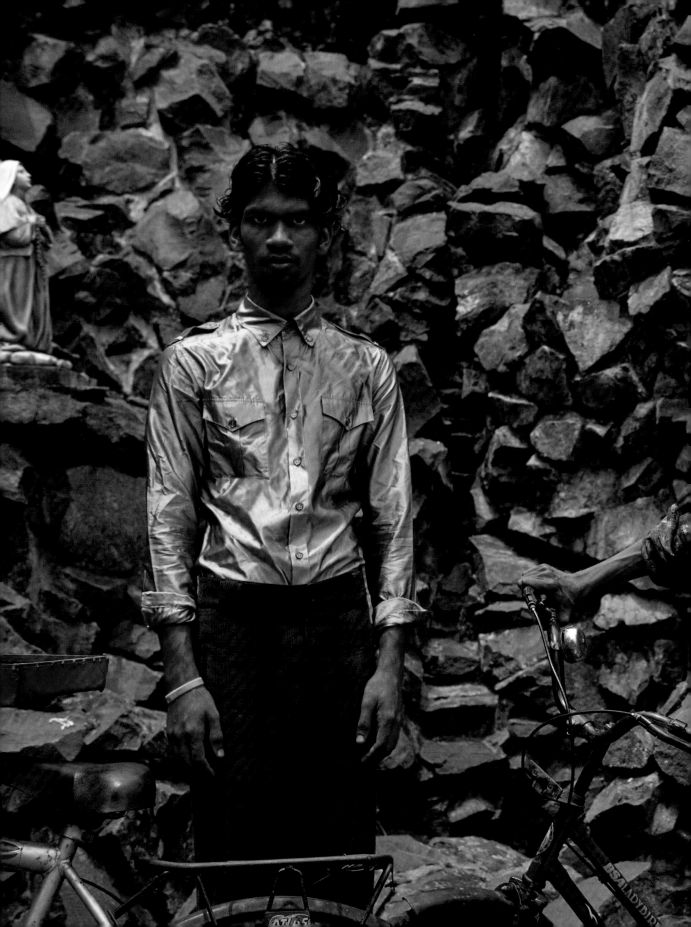

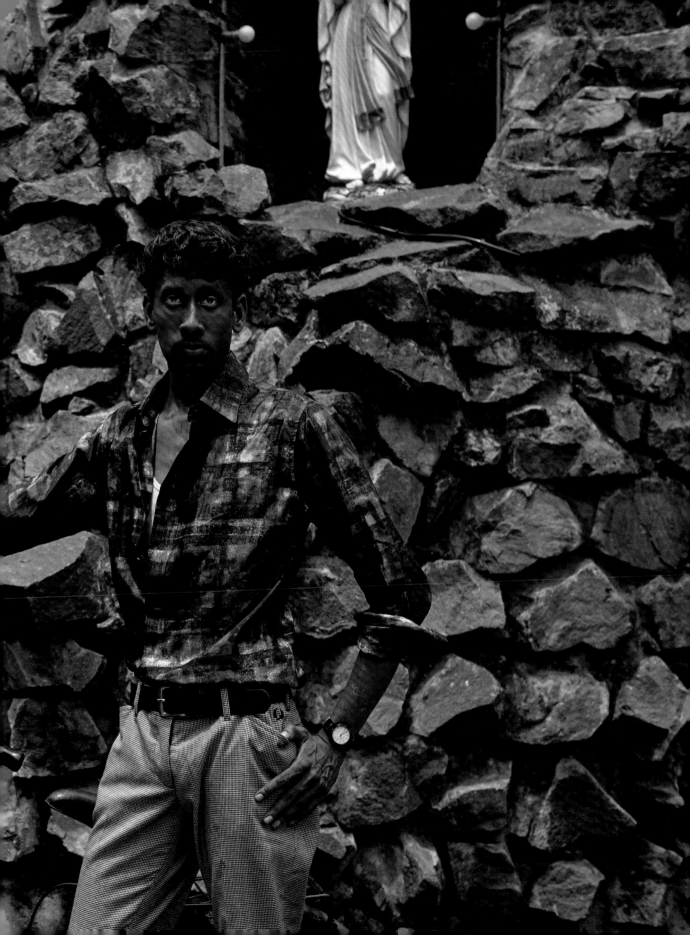

Bodhan Singh, Monkey Temple
Galta Ji. Jaipur, India August 2007

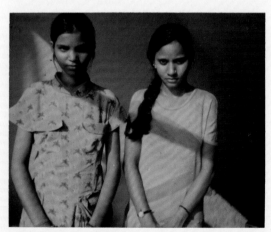

Prada cruise, anna molinarie, gold necklace
(belt worn as necklace) louis vuitton

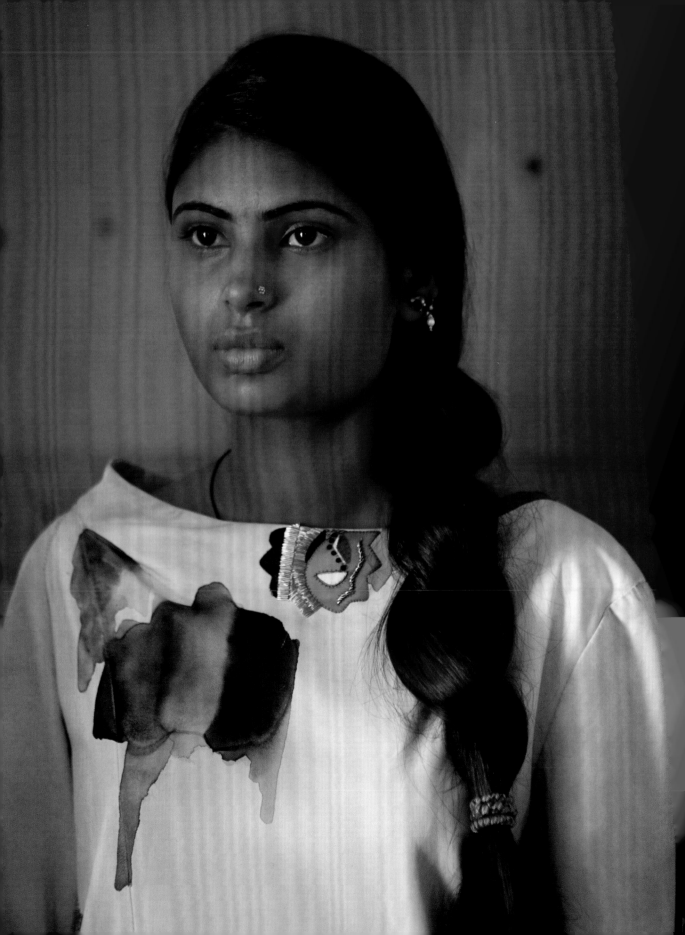

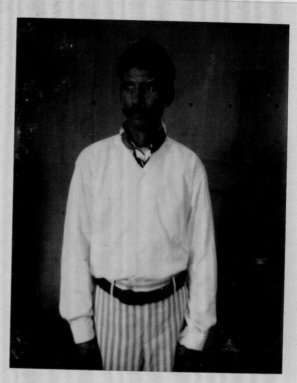

aquascutum, paul smith / chanel scarf (options)

Moust
Man

25

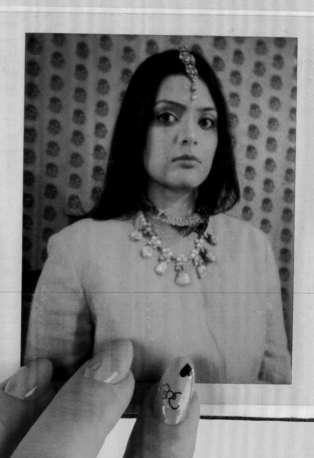

Gem
Palace
lady

31

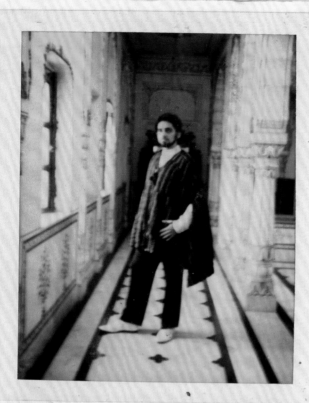

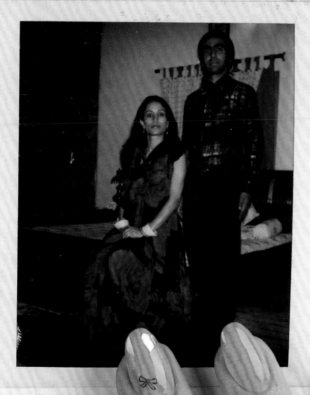

(32)

Young <u>lovely</u>
married
couple.
in their
home

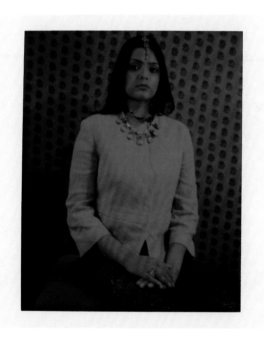

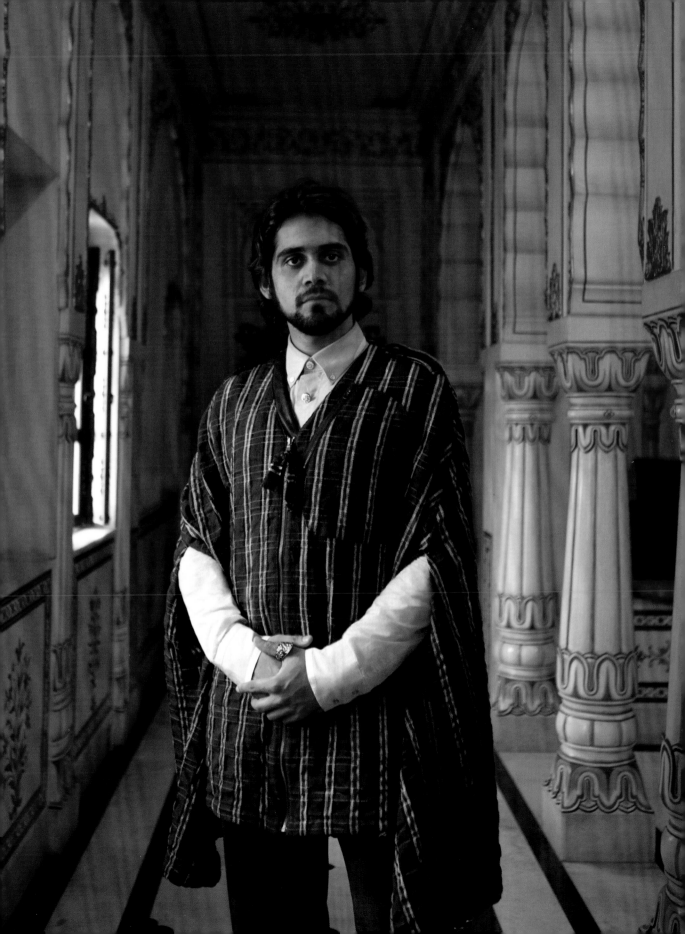

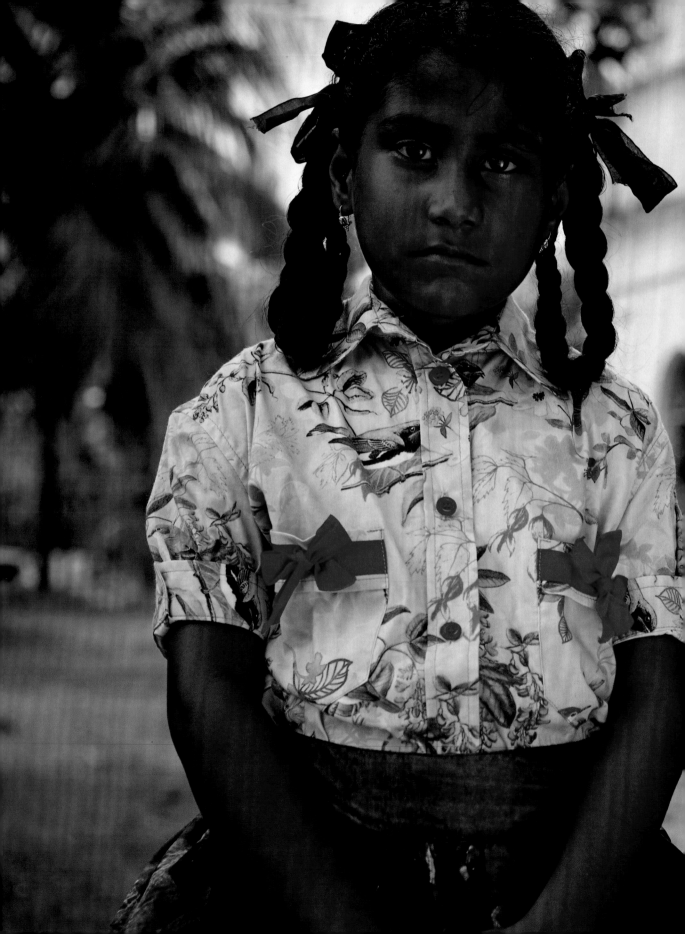

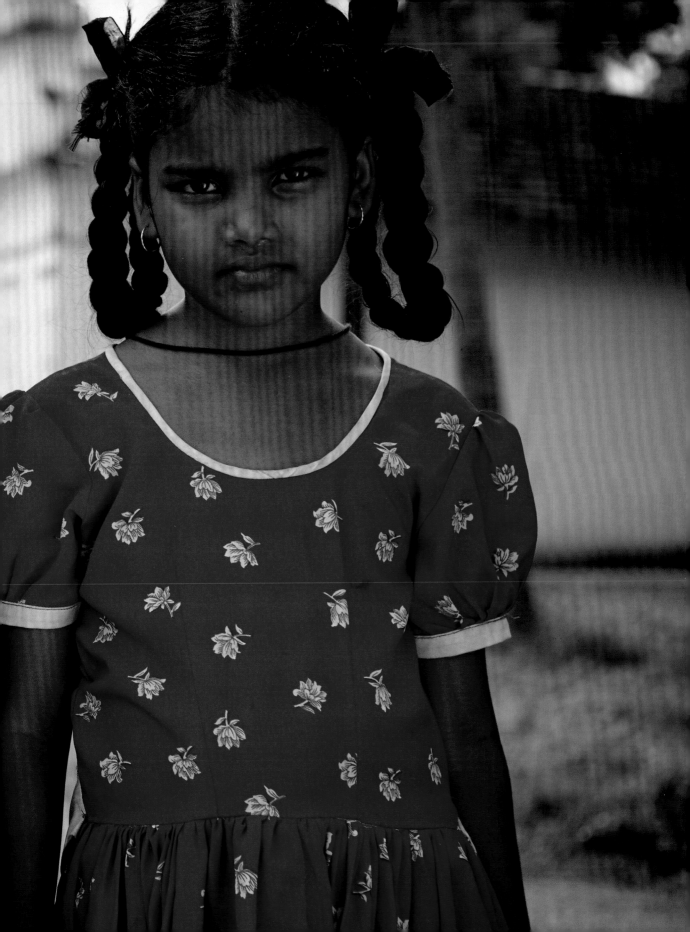

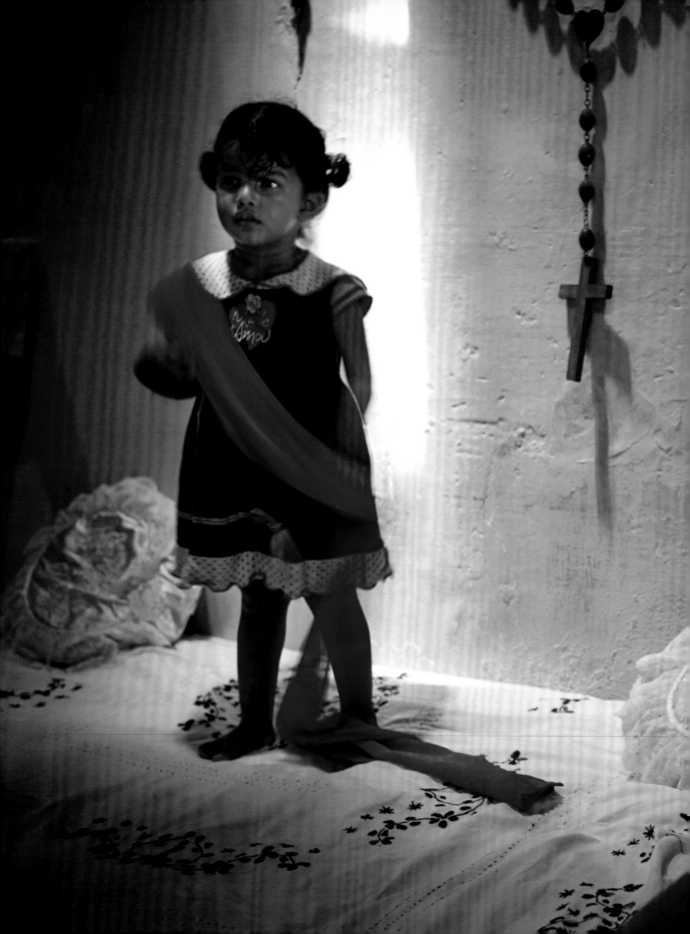

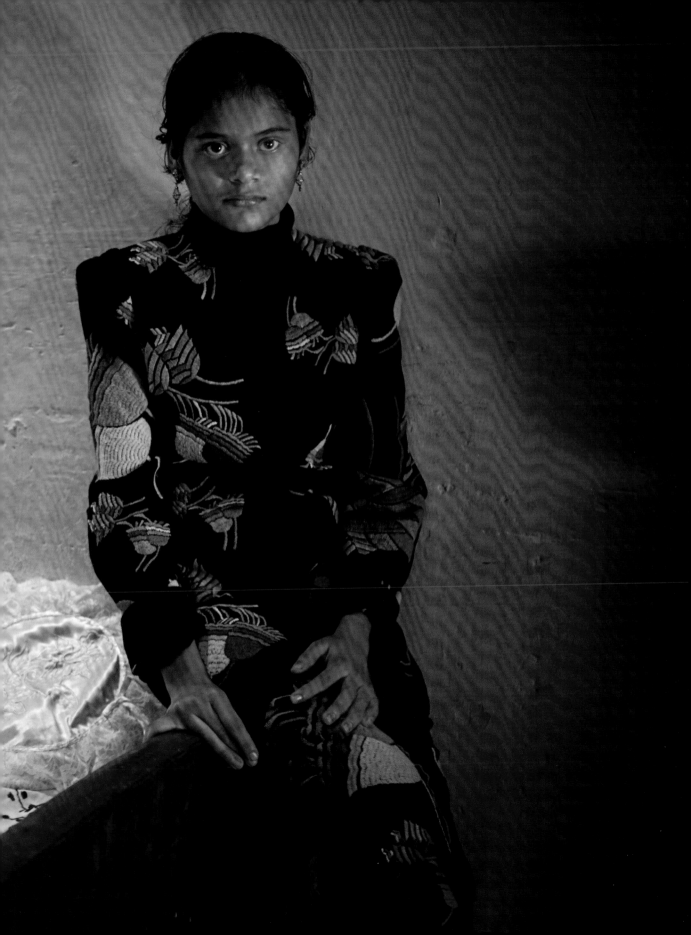

Fashion often needs someone to come along and shake it from its complacency, knock over the pedestals, overturn the status quo and just make it feel alive again. In 1997 when I first saw images by Alice Hawkins, I knew she had the potential to make that happen. I was judging a photography competition for the *Independent* newspaper, and among the hundreds of entries was one set of images that made me way more excited than all the others. Pictures of sports logos – Nike, Adidas and Puma – all shaved into young women's pubic hair. All the judges noticed them; they made us smile, and everybody was talking about them. It was obvious that they should be the winning photographs, but when it came to the vote nobody put them as their first choice except me.

I don't give up easily, so I tried in my most diplomatic manner (arguably not my strongest asset!) to convince the other judges that these images gave the very frisson that should come with new fashion imagery. I convinced a few on my panel, but sadly not enough to earn Alice first prize. The very next season, just over six months later, the new Gucci campaign launched to much acclaim and huge press coverage. By pure and very sweet coincidence, it featured beautiful models with the Gucci logo shaved into their pubic hair.

That is often how fashion works; there is a feeling in the air – a common predictive desire – and those who are most attuned to it become the imagemakers that define our age. There is no doubt that Alice has done that.

Throughout her career, Alice has charmed, aroused, seduced and won over her audience with a mixture of talent and audacity, intellect and playfulness. Her enthusiasm for life, coupled with her inventiveness, is a real pleasure to see and shines through in all her work.

Alice's portrayal of women comes from a feeling of deep respect. Her women are always strong, always in control and always gorgeous. It's a contemporary view of women – one that is not only relevant but also important in these times of censorship and the suppression of the image of women.

Nick Knight

Georgio ARMANI "British Esquir.

GARETH=
07 888888888

dark shirt

Cheeky attitude.

— 9.15am - crew - set up

— 11am - Mr Giorgio Armani

— Equipment Rental
EXIT MILAN
Daniele Gavioni
+35033351333

MAY 1st

BIG PRINT
FOR EXHIBITION.
120 cm wide
170 cm Height

— GROOMING/STYLING
Armani Inhouse team!

FINALS—

— HOTEL: Star Hotels Anderson
PLAZA LUUIGI DI SAVOIA 20, MILAN, 20120
+290 26696691

— ASSISTANT/FILIPPO MEREGALLI +89/333 2333 662

— Retoucher ask Jon Hempstead

— Edit/Email/Decision/upload to Jon/check/finish
(get to Esqire Monday 31st End of day)
DEADLINE.

...on Covers Project!"

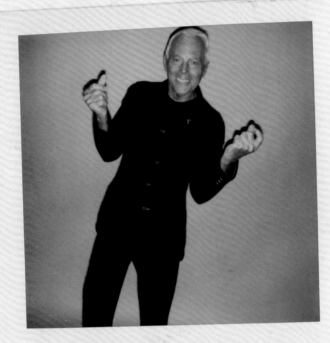

MR ARMANI — MILAN 2008 MARCH

To do List!

— upload to Dave web guy

— Call Alistair re CD images list

—

646 646
5I5I2

Agyness
maids
respond to email

* other photographers

John Bapstiz.

Julian Broad - digital

Agyness 2008
+ Japanese Maid

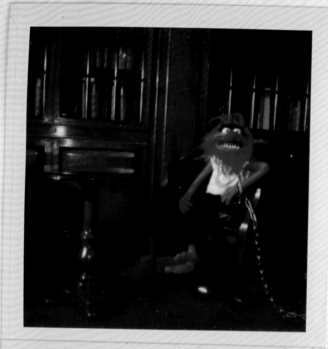

original
'Animal'
From the muppets
@ In & Out Club
Berkley Sq W1
&
Stringfellows Ange
Wardour st.
Soho.

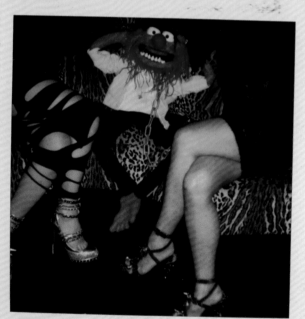

Animal @ Stringfellows, London
2008

animals?
ve

mail Cavilli
by and ask
for names
of Cavilli's
pets.

give a
decent
shot of
the mares
to fit

Roberto Cavalli
Florence Italy
Sept 2008

- call Sue 01817490597
- Call Pheobe
- Gabi cavalli
 - 7am
 - 8am.
Sunday Flight / Gatwick / - 9.45 am

10 x 4 ft
PORTRAIT
- Save 10 images
 for the
 windows

<u>Alistair</u> - Return Contract
 - Application hang on till Monday
Gallery - The PUMP House - South London
 email - British Press - magazines
(Show 2nd December opening) from
 to mail

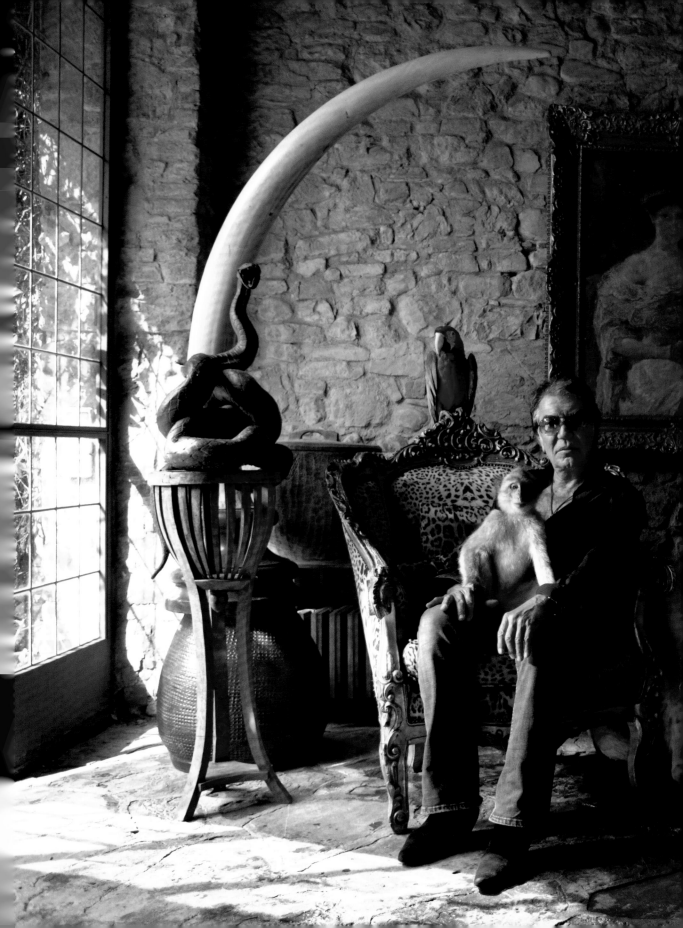

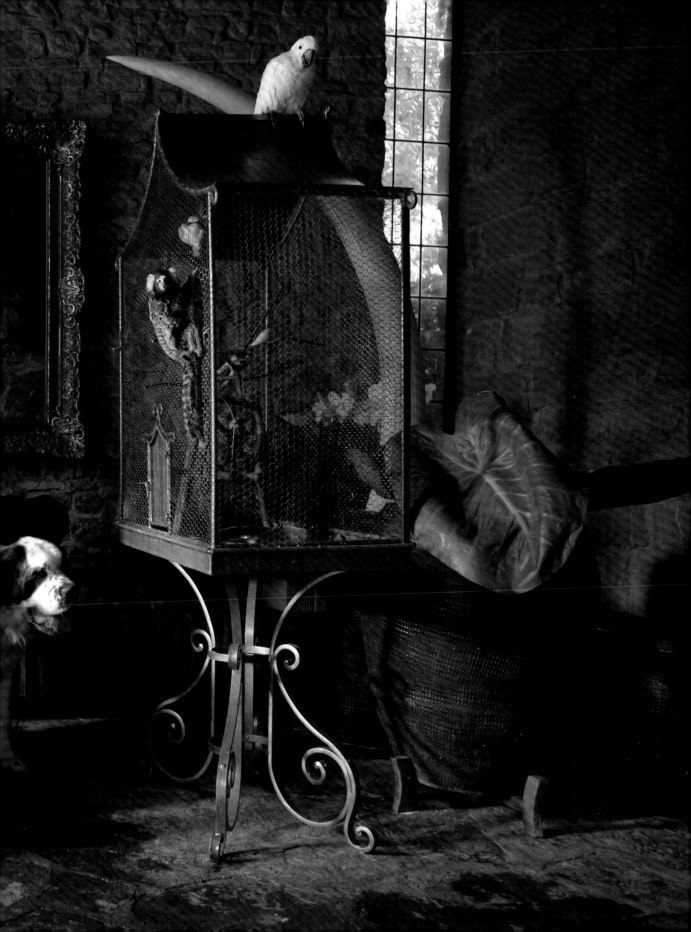

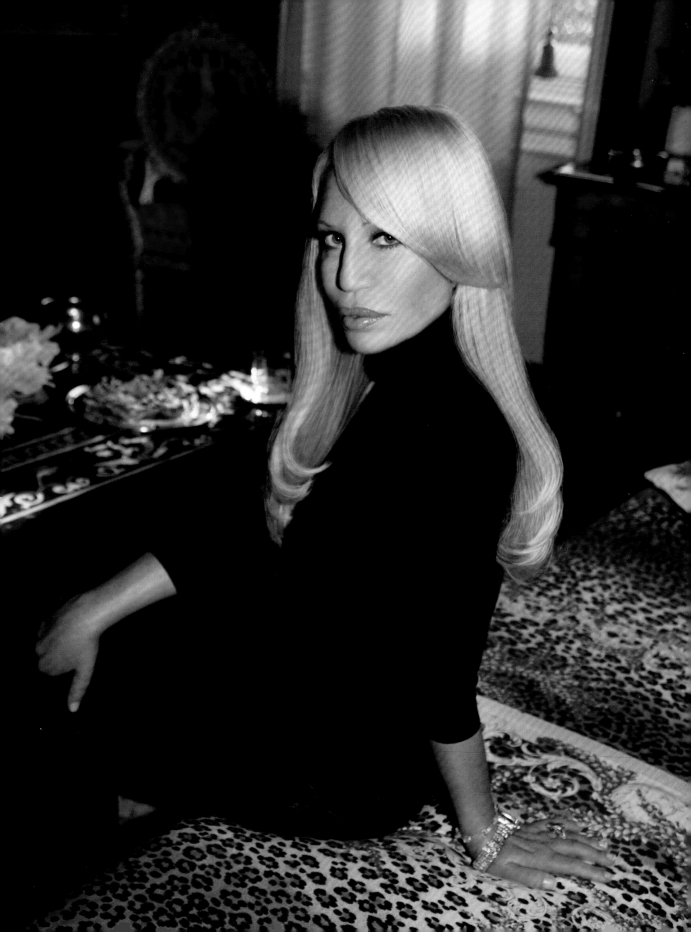

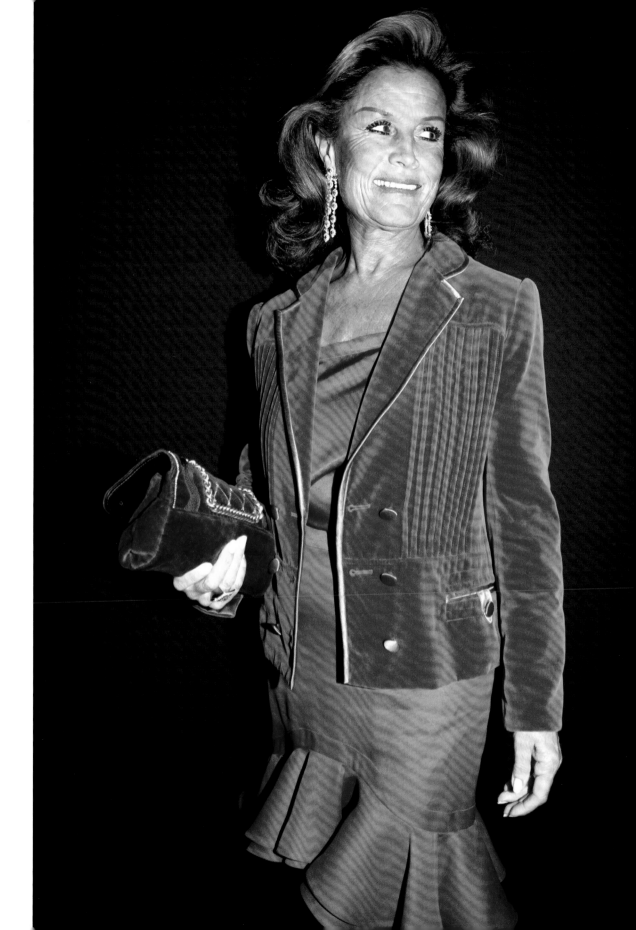

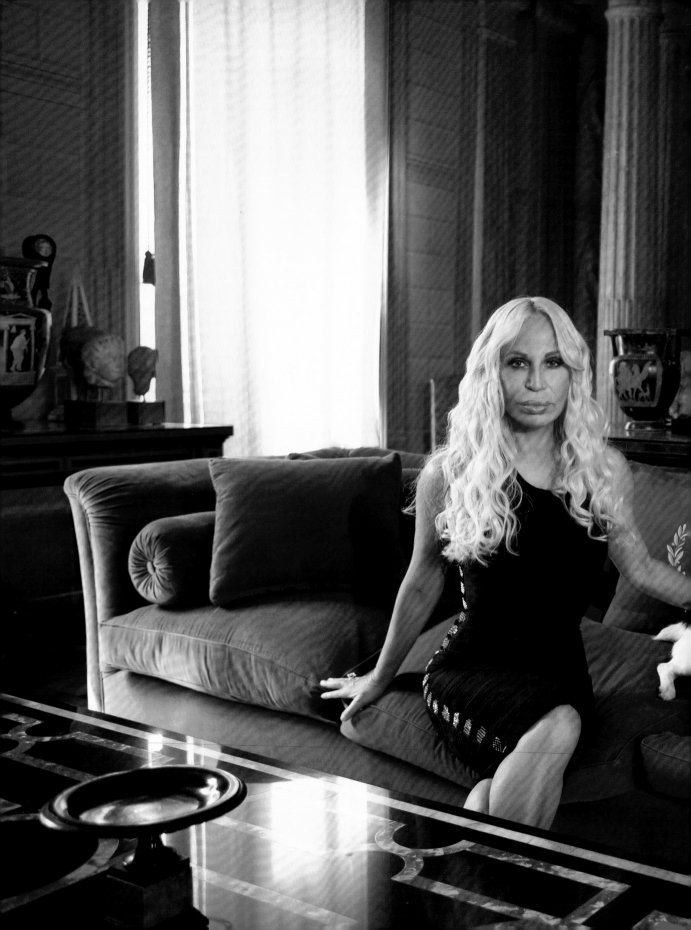

SUN - CAB 780 ✓
MON - 13th:

TUES - 14th:

WED - 15th:

THURS - ⊞

FRI - 17th:

TAXIS T[

ARMANI: GIOIA BONOMI
in her mother-in-laws house!
- complete with James Bond Styley
Butler.
(Sam/Lisa fav)

MAXMARA LADY:
SIRI WILLOCH
VIA PORTA LODI
25200 MONZA (MI)
ITALY

She wants to
see my website
↑ /work.
email her.
make sure she
gets a copy of
the magazine.

↓

let her know
when I'm going to
N.Y. so she can
give me list of
ART BUYERS.
to go see.....

Dolce & Gabbana - Maria Buccellati
Max Mara - Siri Willoch
Missoni - Margit Cesana

ARMANI - Gioia Bonomi
CAVALLI - Rachele Cavalli
Anna Molinari - Uberta Zambelletti
BURBERRY - Maria Sole Brivio Forza

Bottega Veneta - Ottavia Giorgi di Vistarino

Alessandro Dell'Acqua.

Etro
Fendi

Prada - Eva Herzigova
Versace - Barbara
'IL SANDER - Francess
'IICCI - Virginie

do myself

125
Magazines Sent:
adam Bomb ✓
ace ✓
steevi ✓
Trevor Jones ✓
Glen ✓

Jolyon
steevi Bacon
Gemma

milan trip: Barbara in Versace: MILAN COLLECTIONS HARP
Want this image asap. (March 2005.)

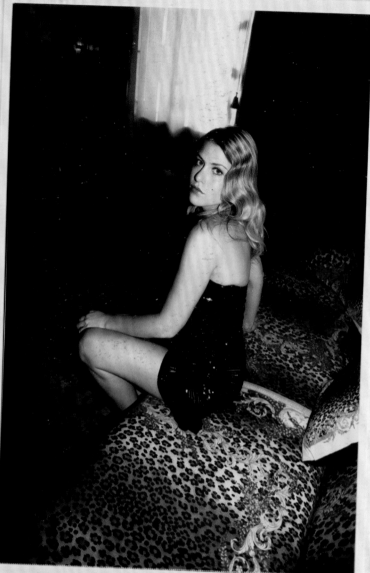

abit too Sexy for her dad!!!!
 apparently!!

I first met Alice Hawkins at a desert oasis in the middle of nowhere, a defunct horse ranch now given up to silence, scattered clusters of cacti, and an old grove of tall palm trees that encircle a small pond called Resting Springs – a famous watering hole that for centuries served as a stopover for lone plainsmen and explorers such as John C. Frémont and Kit Carson, and dreaming pioneers testing their luck and endurance on the Santa Fe Trail en route to the Gold Country. Alice and her stylist Samantha Willoughby were there that night to attend a staff party replete with a hard rock band and tables of sumptuous food that had been brought in all the way from Las Vegas, a hundred miles away. This turned out to be the right setting for my first encounter with Alice, for she herself is an explorer and a world traveller – essentially a nomad with the song of the open road in her blood, catching the moment as it flies in her art. And she is always making new friends on her journey, and those new friends lead her still further to other adventures and to other people and places, which inspired me to write a poem that describes Alice as I know her.

Song of Alice

As long as I have eyes to see
and a heart to care,
I'll go as the road goes everywhere,
true to the friends and company
I meet or part with there.

She is keenly alert to the atmosphere that surrounds her. I have seen her in the midst of conversation with friends in some outdoor setting suddenly raise her camera and take a photograph of something that caught her attention while still talking, never missing a beat. It is this unfailing eye for the instant that has resulted in some of her most poignant and striking photographs. You ask her how she does it – why she is so lucky – and her answer is that she creates her own luck.

In many of her photographs she turns to the desert again and again for new inspiration in her work and fresh meaning in her art. She is drawn to its austere ruggedness, its infinite silence and the sense of the changeless amid change. To her there is something about the desert that renders our modern life and civilization ghostly, temporary, doomed to non-existence; all our over-civilized luxuries, synthetics and mechanized lives suddenly seem like tinsel in the vast timeless setting of the desert. It is the dramatic contrast between man and nature in our time – their fatal opposition even – that much of Alice's best work seeks to express.

If it is the goal of art to rescue a moment in time from the flux of existence and capture it in some living form, then Alice's photographs can be justly termed the work of an artist, and what an artist!

Mark Haywood

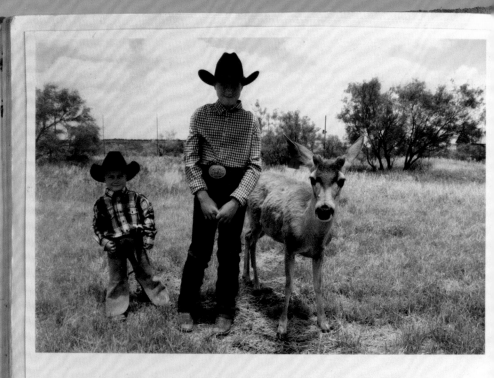

Cash & Roder + their pet deer – on their RANCH in canyon amarillo. TEXAS. – JUNE 05'

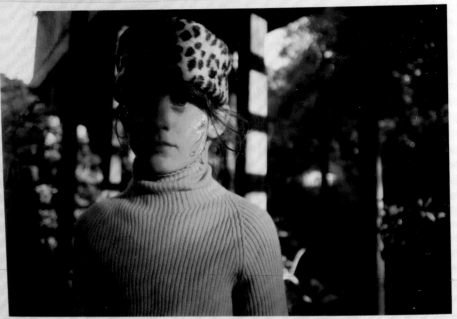

OLIVIA – AUSTIN. Scott's daughter 8 years

ardas + ordus – Brownwood. Texas. (80 year old twins)
TRUCKERS CAFE – "RED WAGON" Local mechanics.

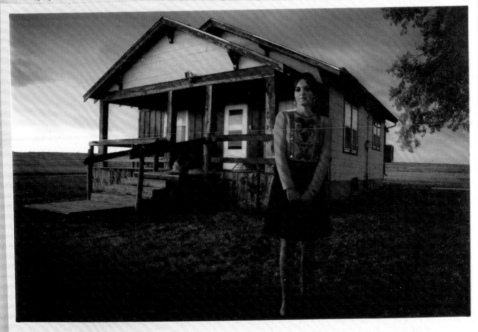

SHAUNA – AMARILLO TEXAS.

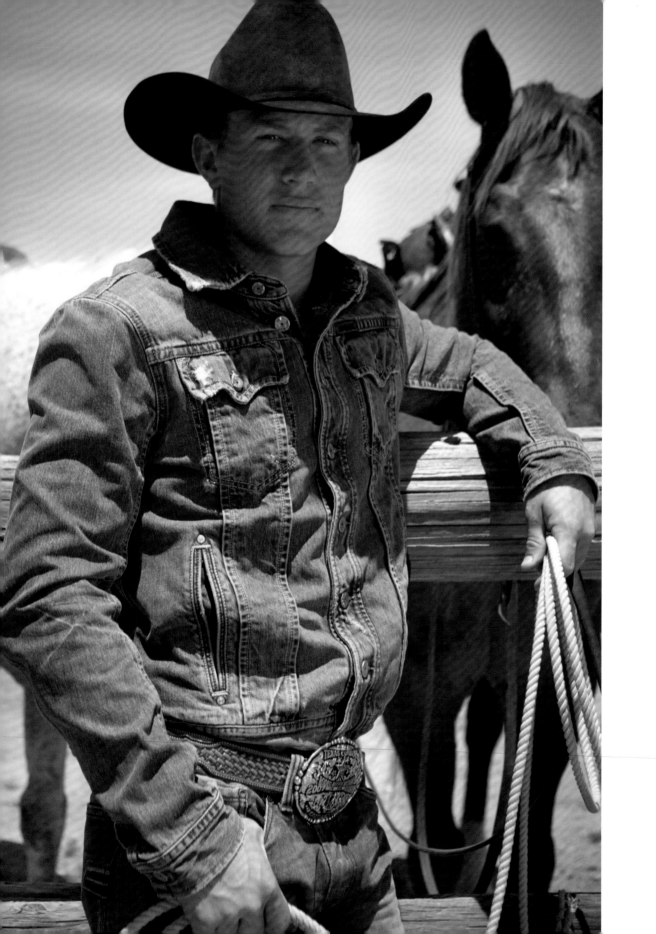

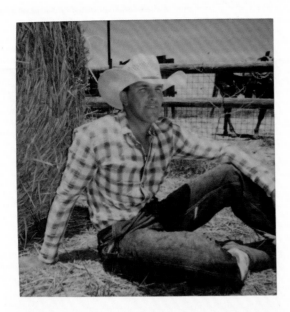

Jake, Crutch Ranch, Texas

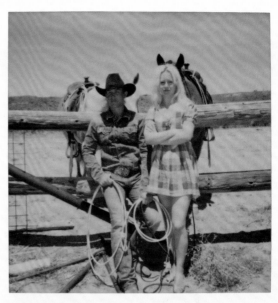

Reese Riemer + me, Texas

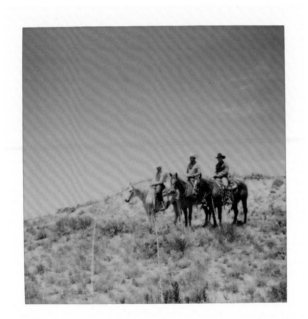

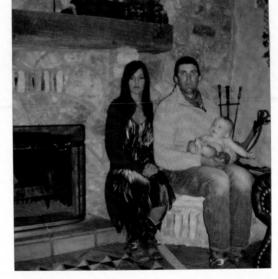

Shawna + Hegan
Texas

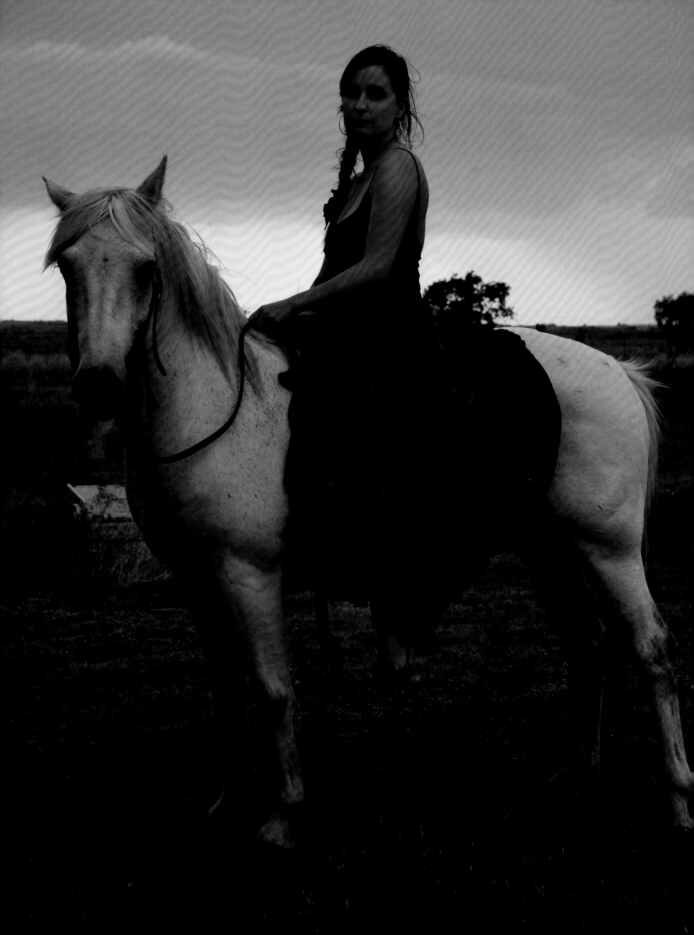

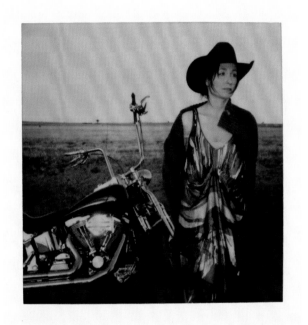

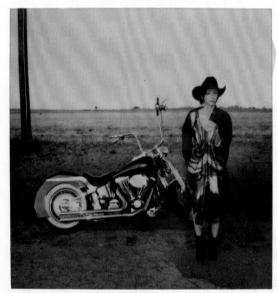

Kori ♡ Texas Queen

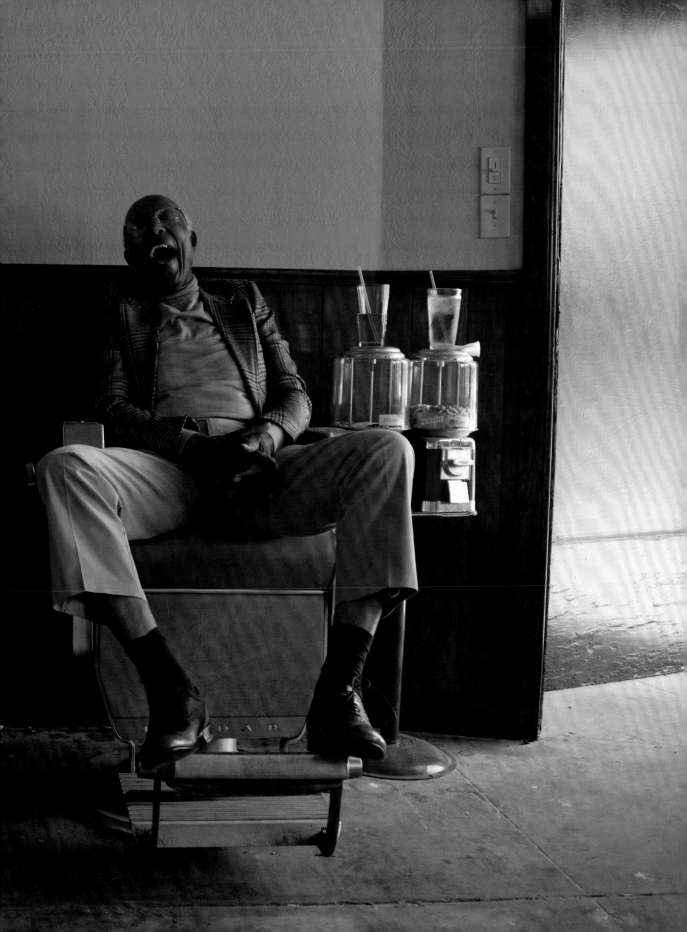

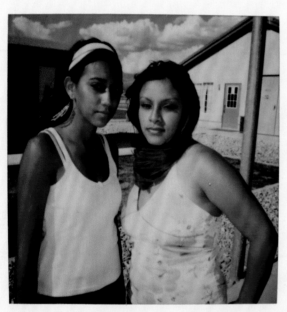

Girls, teenagers in Pahrump
Nevada. dusty desert town
casting for my pop magazine project.

It's hard to find subjects to photograph in the
desert - its mostly full with tourists rather
than locals. So I decided to make Walmart in
Pahrump Neveda. Day 1 we found these sibling
-s and their mum. We went to their home. 2007

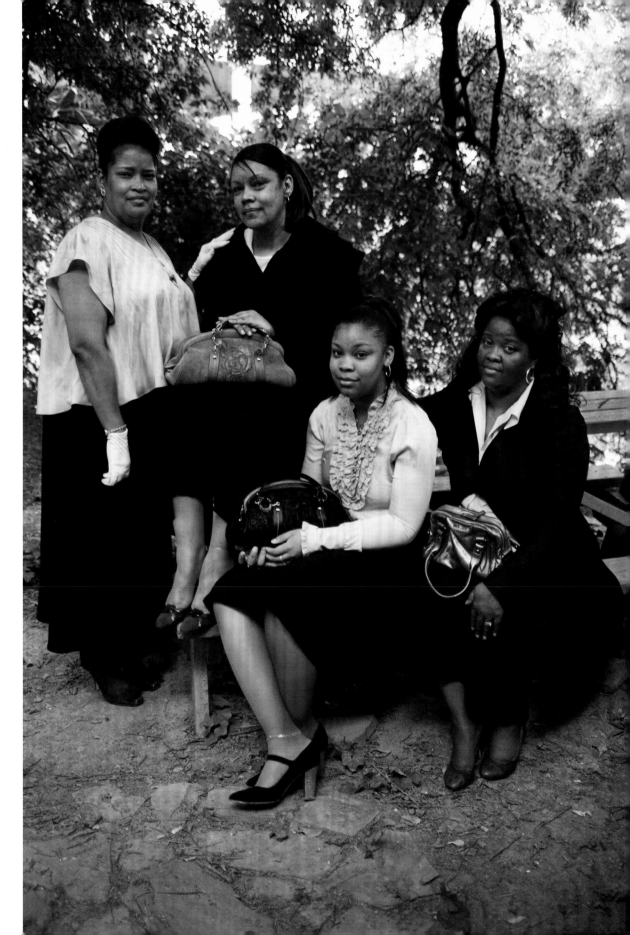

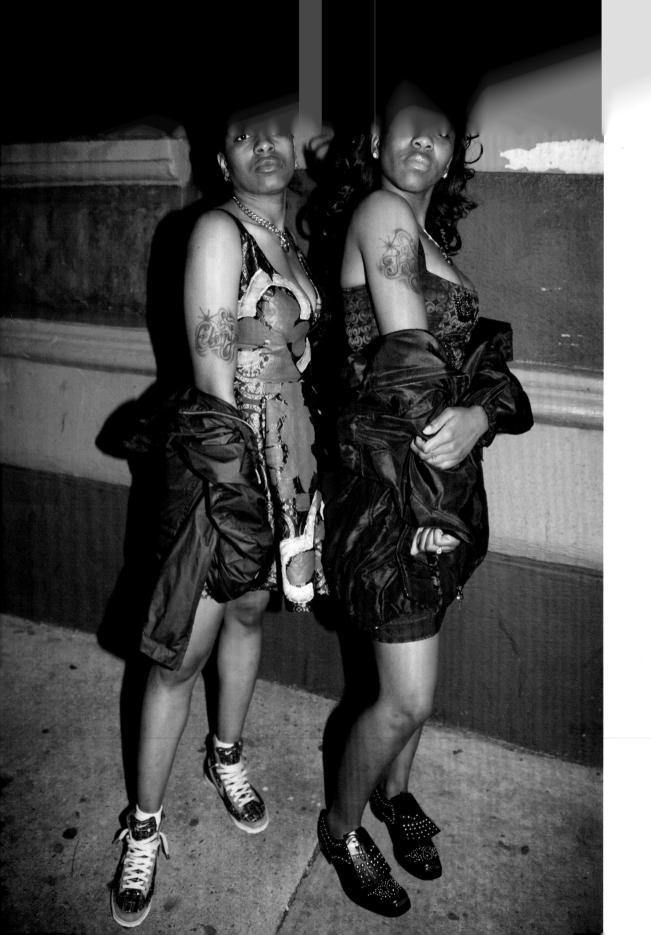

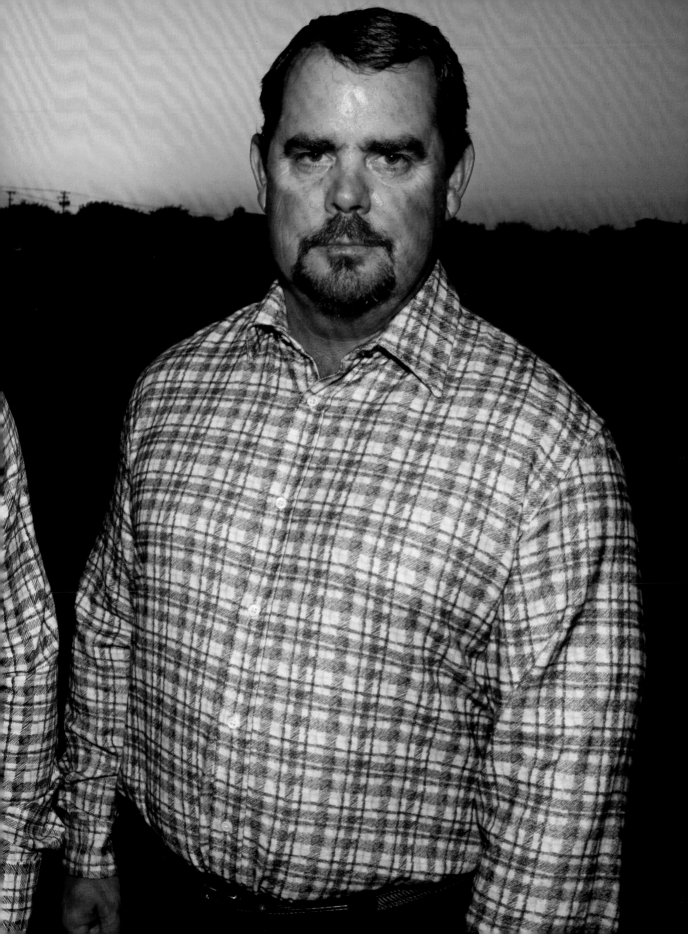

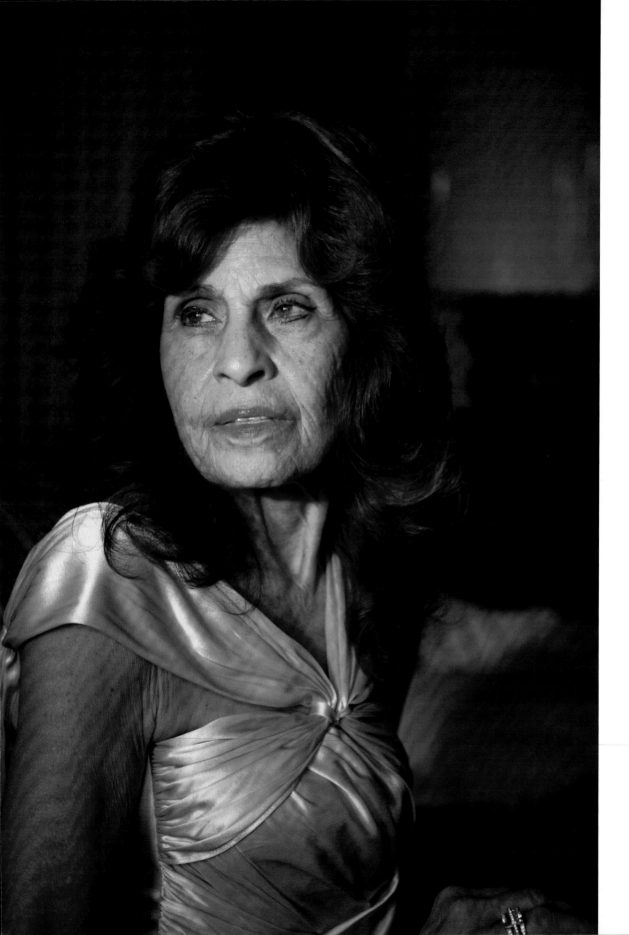

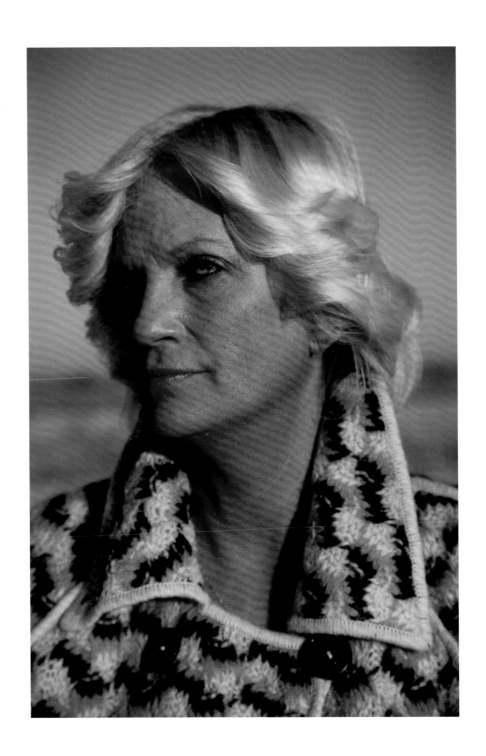

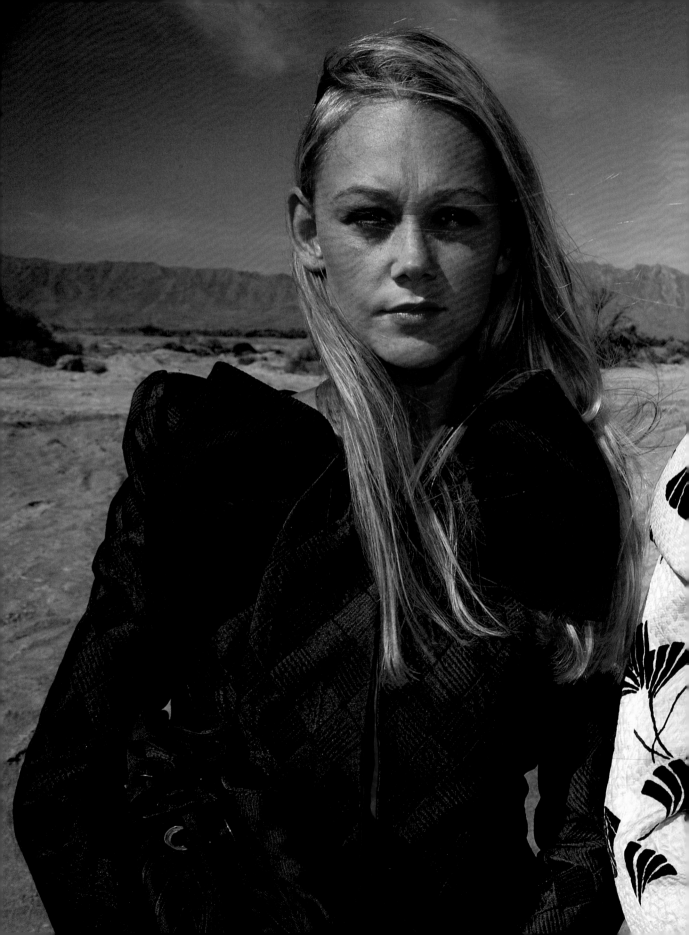

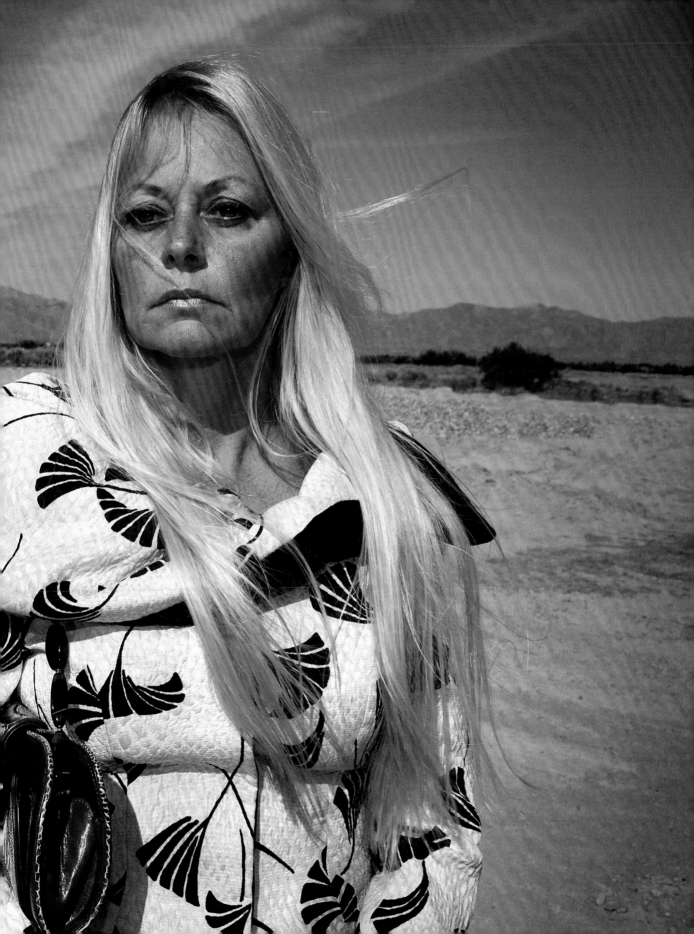

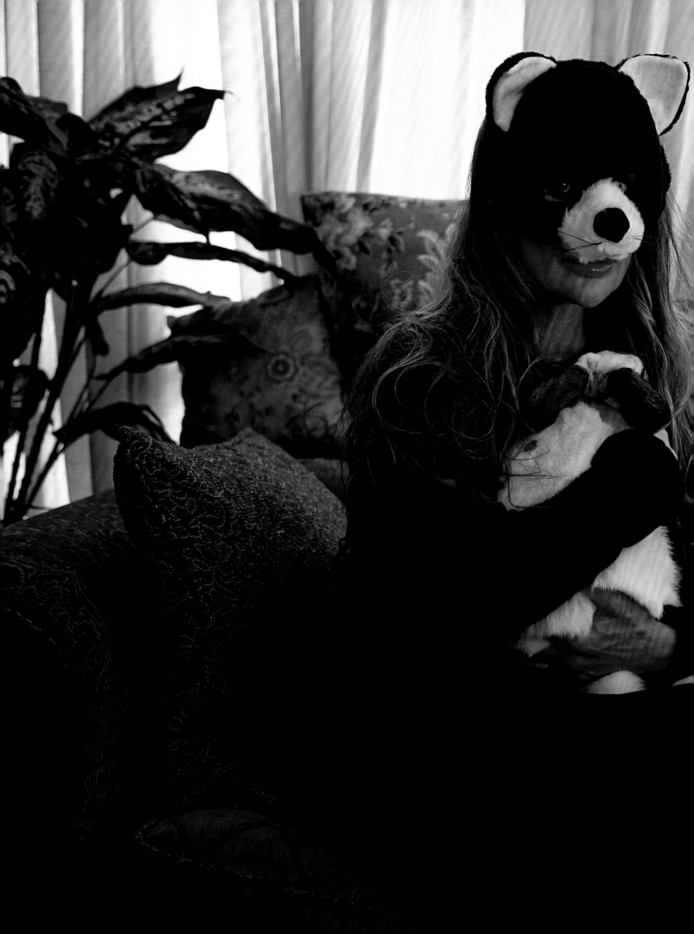

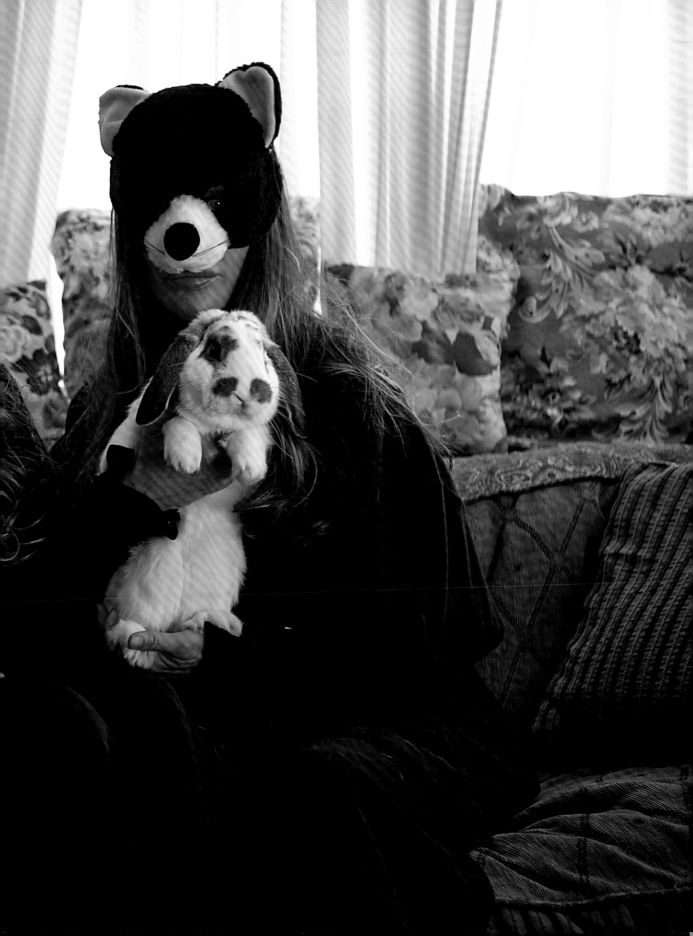

Drive from Vegas / Death Valley to San Bernadino, Thursday May 8th to Shane + Gloria from Animal Actors - first stop and meet Sid

Rowdy the Monkey was in the film Pirates of the Caribbean.

Lina Kimball 8/5/08
+ Brooke Thompson
+ "Rowdy" - capuchin monkey

Trevor
&
"Cheyenne"
the grizzly +
Boomer &
Blaze
C.A.

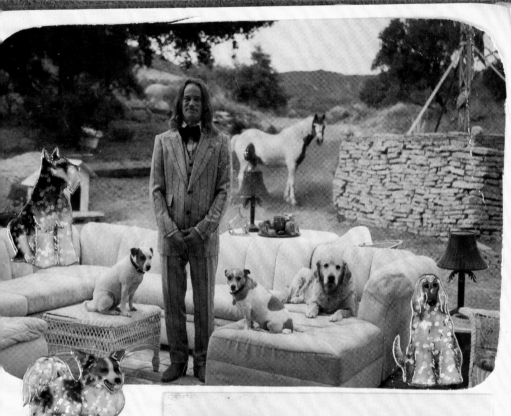

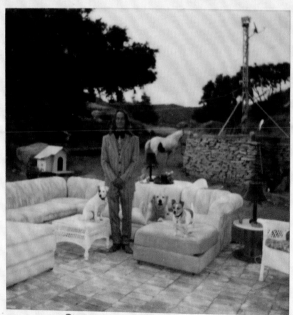

THIS IS SHANE
-HE IS A CLINT
EASTWOOD
STUNT MAN
/DOUBLE IN FILMS
He is married to
Gloria
they are
the
BEST !!!

Shane. sonny Tiki spot

MAY. picassco
2008 Lake Elsinore .CA.

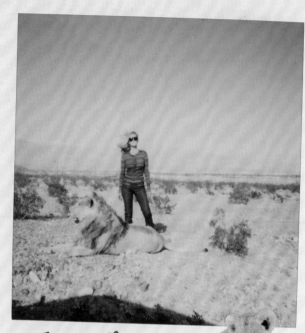

Zuzana ♡
♡ & "Bam Bam" ♡
♡ the teenage lion,
 near Las Vegas . N.V.

I have to confess that we decided to do
this shot with Bam Bam from
the safety of our SUV rental in
Zuzanas back yard (which is huge
as you can see)!! We did this because
Bam Bam is
a naughty
teenager!!
You don't
want to mess
with teenage
Lions!!!

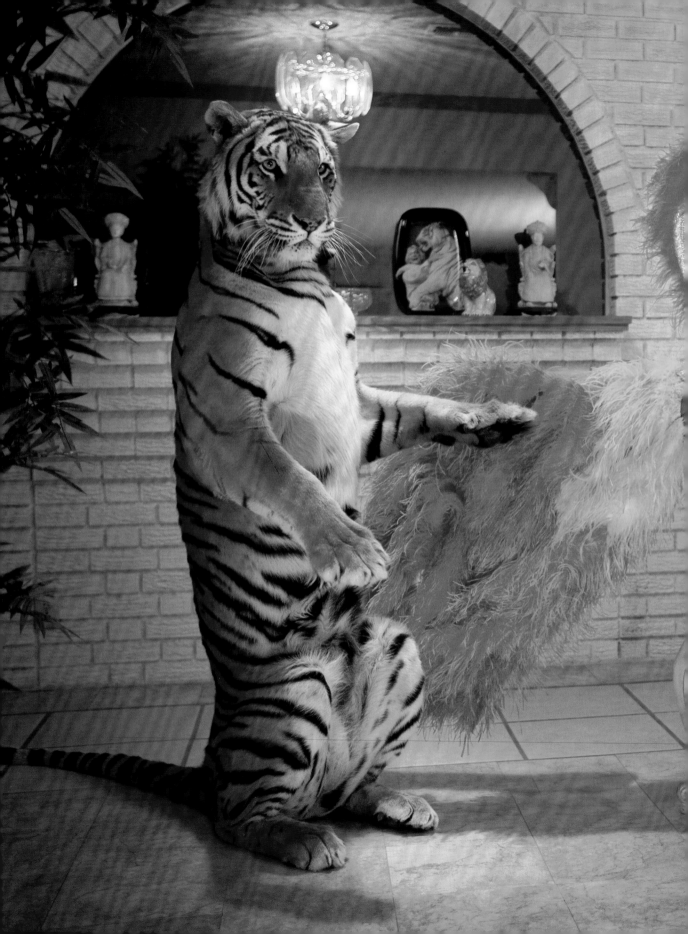

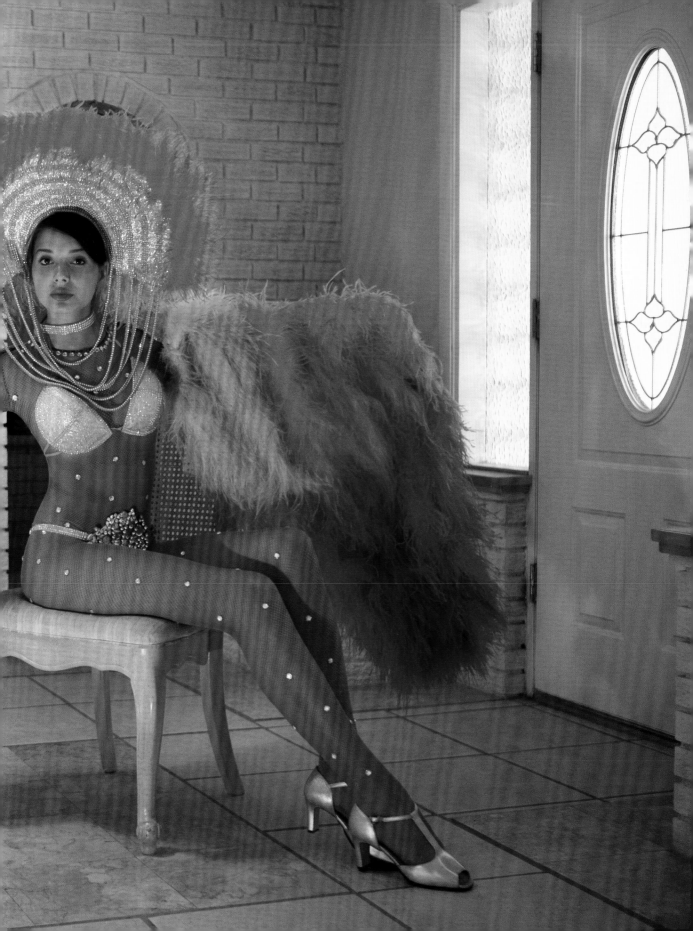

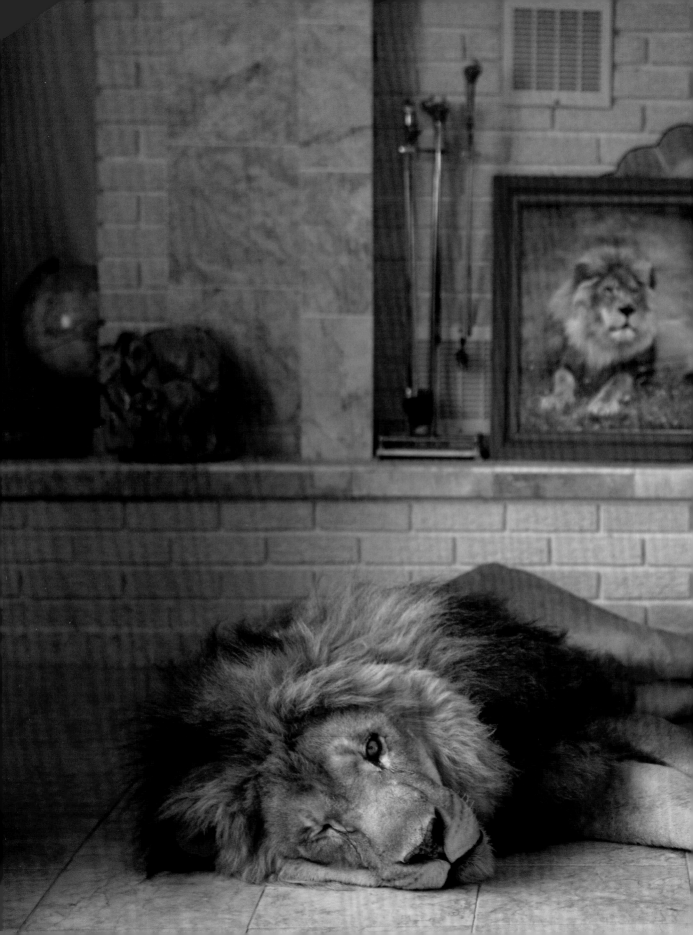

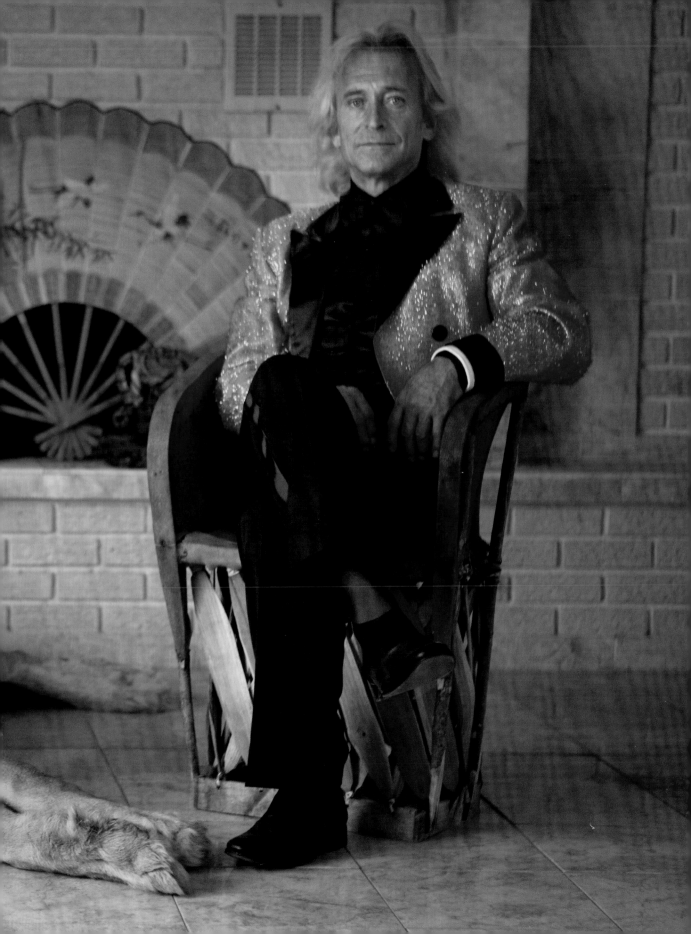

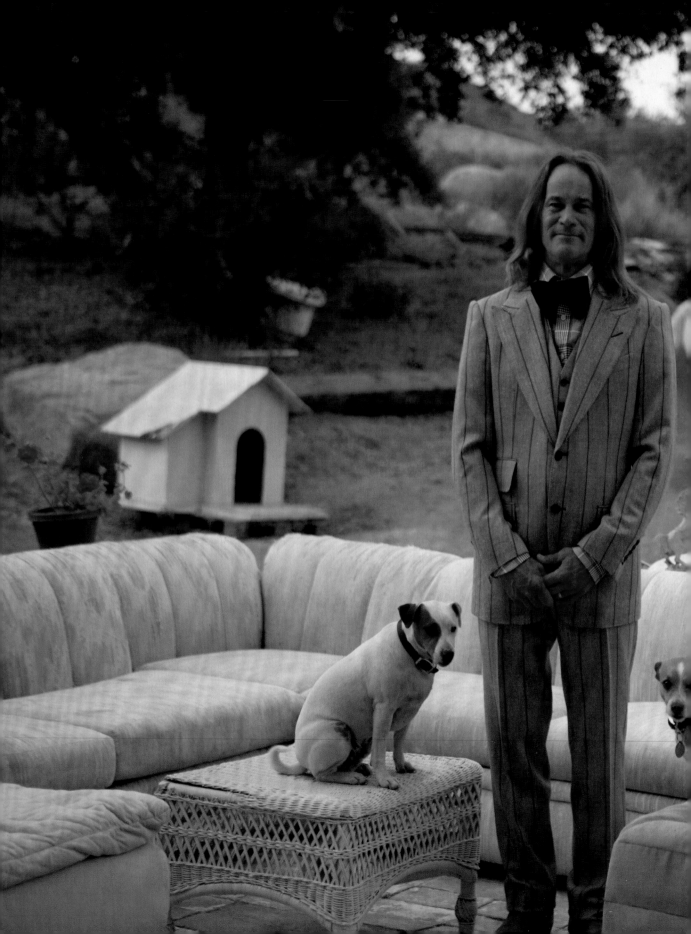

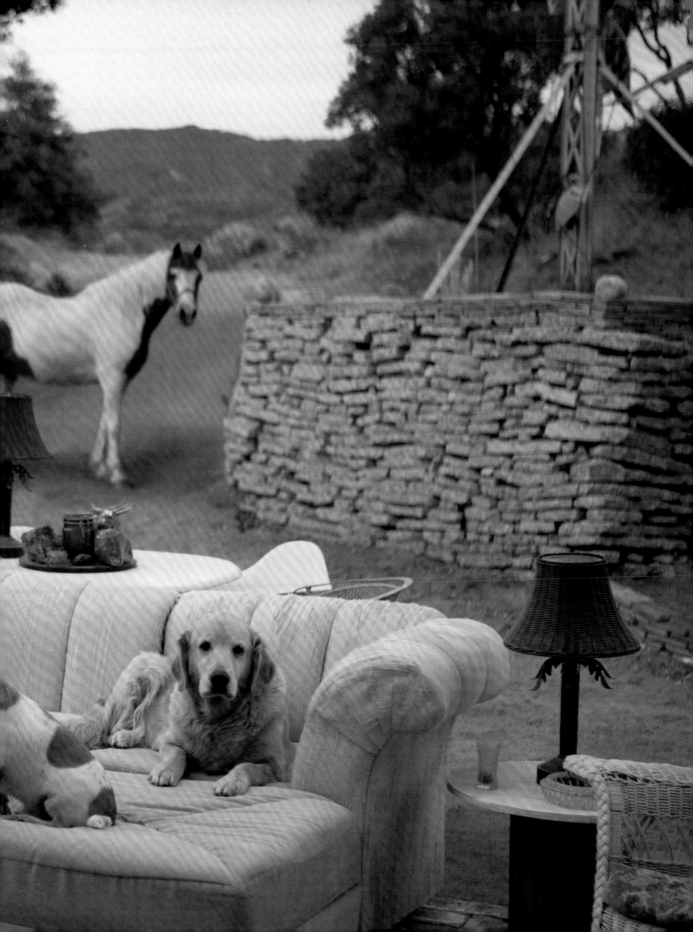

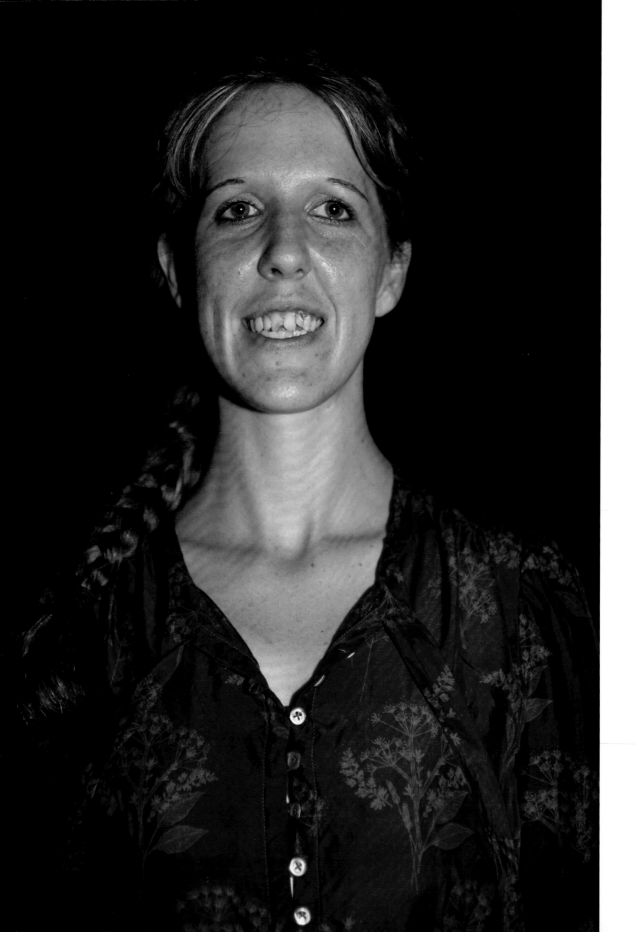

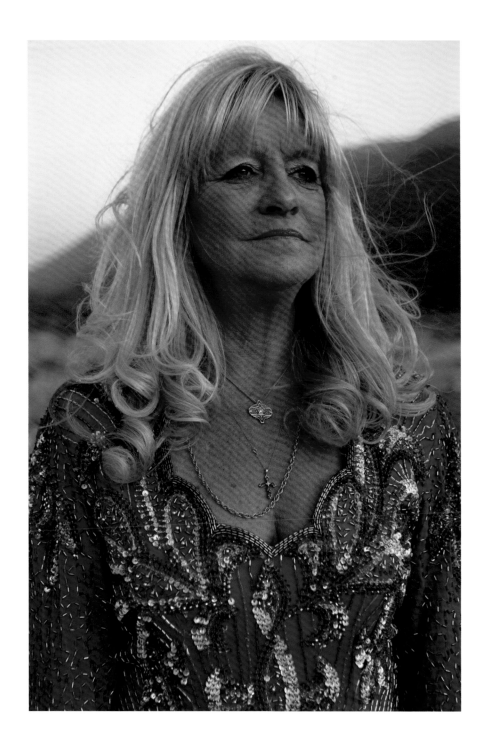

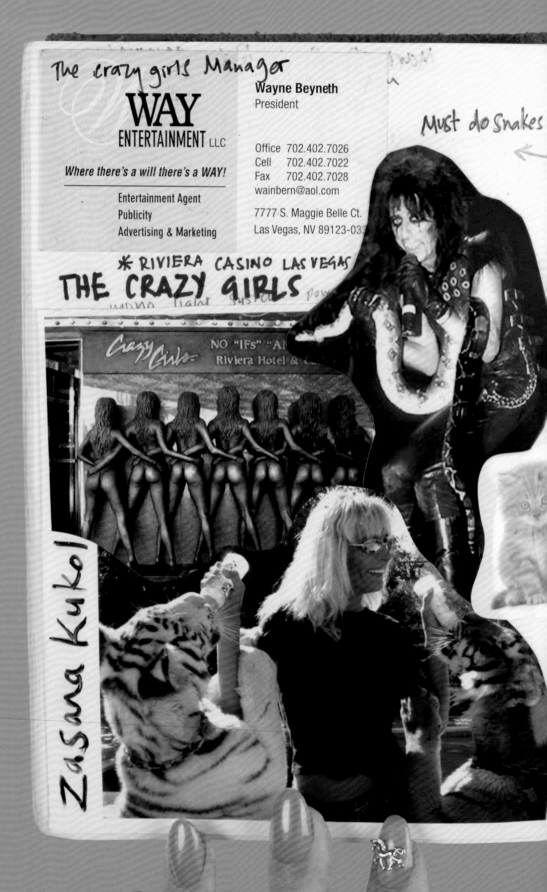

The crazy girls Manager

WAY
ENTERTAINMENT LLC

Where there's a will there's a WAY!

Entertainment Agent
Publicity
Advertising & Marketing

Wayne Beyneth
President

Office 702.402.7026
Cell 702.402.7022
Fax 702.402.7028
wainbern@aol.com

7777 S. Maggie Belle Ct.
Las Vegas, NV 89123-033

Must do snakes

*RIVIERA CASINO LAS VEGAS
THE CRAZY GIRLS

Zasana Kukol

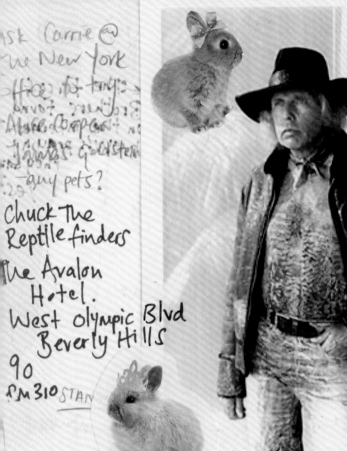

ask Carrie @
the New York
office about tony's
tarot cards...
Alice Cooper +
James Goldstein
...
– any pets?

Chuck The
Reptile finders

The Avalon
Hotel.
West Olympic Blvd
Beverly Hills
90
RM 310 STAN

A friend told me
about this bloke
called James
Goldstein, in
LA. He is like
a billion
-aire who
loves fashion
– then I reme
mbered saw
+ I met him
at a Gucci
party in
Milan.
He was
very cool.
Looks like
all his cbts
are made from
Animal skin
OR reptile
skin. He look
abit like
croc
dundee !!!

James Goldstein
L.A. Hollywood

Soft Box

Speed. throw (take the Blk off lining - so just clear white material)
diffusses the light more
silver lined umbrella - harsher light / reflects more

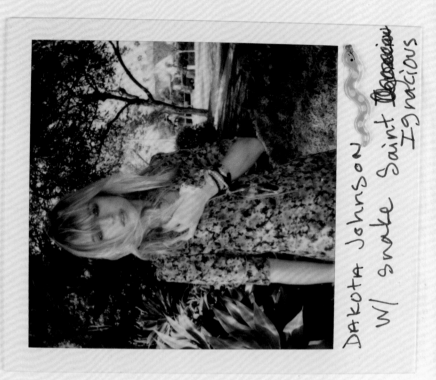

Dakota Johnson
w/ snake Saint Ignatius

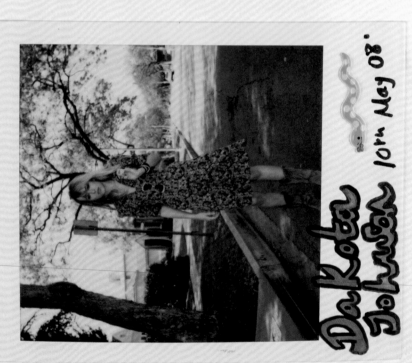

Dakota
Johnson 10th May 08'

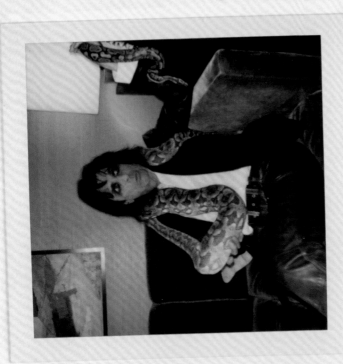

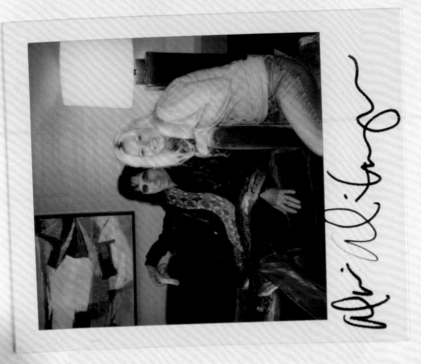

Hair: Janine Jarman / Hairroin Salon
1533 Cahuenga Blvd
Hollywood 90028.

Makeup: Carlene K. for Urban Decay

CREDITS:

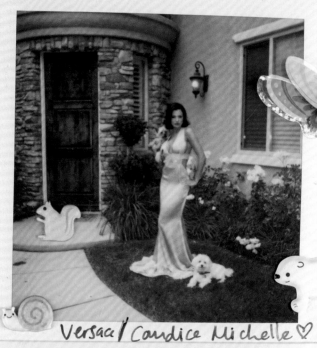

Versace / Candice Michelle ♡

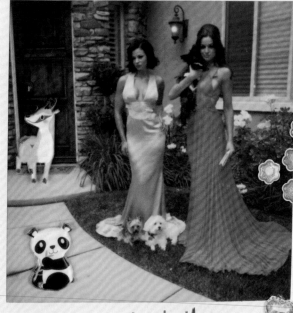

Candice Michelle &
2008 Maria white dog: Bam Bam
two A... Beverly Hills Little Betty Boop- mini Yorkie !
 Black dog: Gemini

Candice + Maria are WWE wrestling
girls!! ♡ They are very fit + sexy!!!

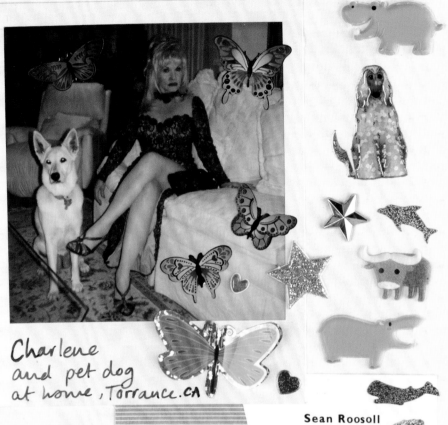

Charlene
and pet dog
at home, Torrance. CA

B|W|R

P u b l i c R e l a t i o n s

Sean Roosoll

310 | **577-7776 Tel**
 555-1111 Fax
 srooroll@bwr-la.com

5757 Wilshire Boulevard
Suite 555
Los Angeles, CA 90000

World Wrestling Entertainment, Inc.
www.wwe...

JOIL ILLA
Publicity Coordinator

1212 East Main St.
Stamford, CT 06969
Tel: 203 359 3595
Fax: 203 359 3599

joil.illa@wwecorp.com

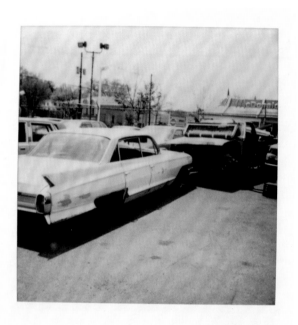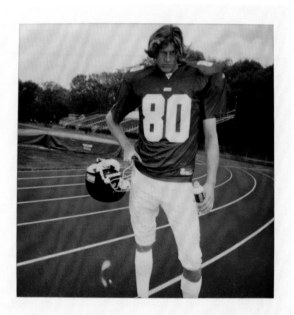

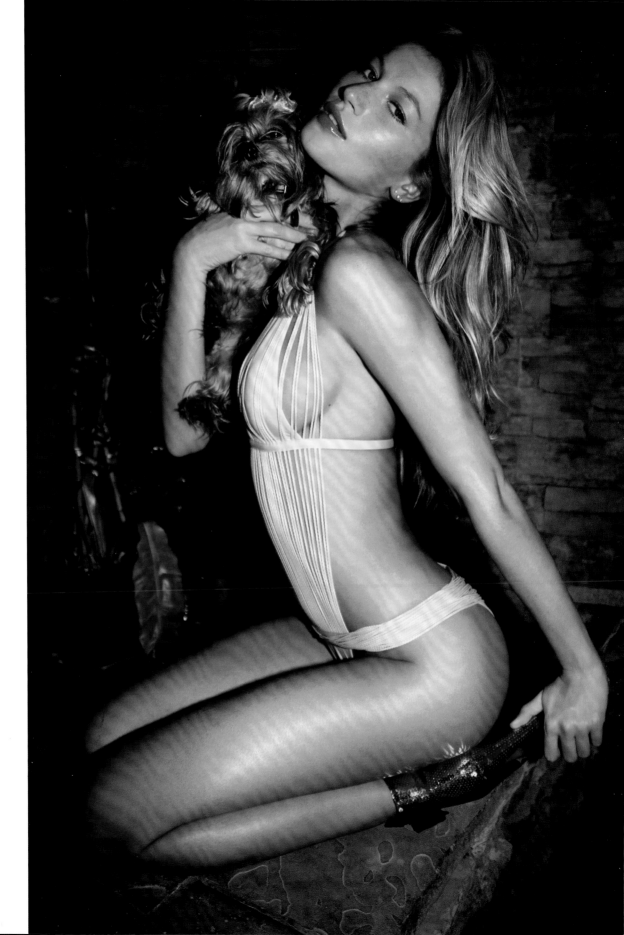

5pm-7pm
Will @ NYM
273 2nd Avenue @ 9th St.
Apt 7
Cell: 967 777 5552

7pm-9pm
Micael Lucas
333 West 33rd St. #7 1001.
917 333 3333

► LUCASBLOG.COM
► LUCASENTERTAINMENT.COM

MICUELE LUCAS
President

MOBILE 917.100.0000
MICUELE@LUCASENTERTAINMENT.COM

← Male ♡
Porn ♡
Star ♡
#YES!

VERSACE

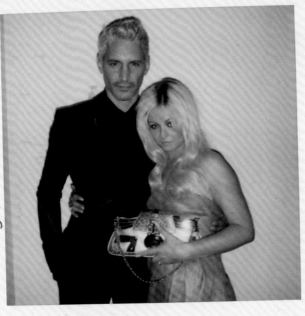

Tony + Me (Sugar daddy!) ♡
i-D mag / Versace Hunks.

♡

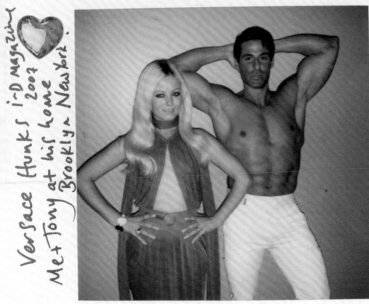

Versace Hunks i-D magazine
2007
Me + Tony at his home
Brooklyn New York.

Me & Tony!!
← Oct 2007.
My favourite
HUNK!!
like a disney
dream character
married to
Tina & has
dog Tiny!!
a blend
of both
names
TINY
N.Y
2007

I ♥ TONY

Oct 2007:

HUNKS in NY.

Dai (Hair) 646 522 717 } MANAGEMENT
Mika (assist) 646 235 868 } ARTISTS
Dotti (Makeup) 646 . 714 . 476 }
 Stylist – Michael Phil @ NY
Donna 866 988 086
Douglas perrett : 917 643 633

VERSACE	HUNKS ♥

mon/Sunday.

Mark: 401 569 696

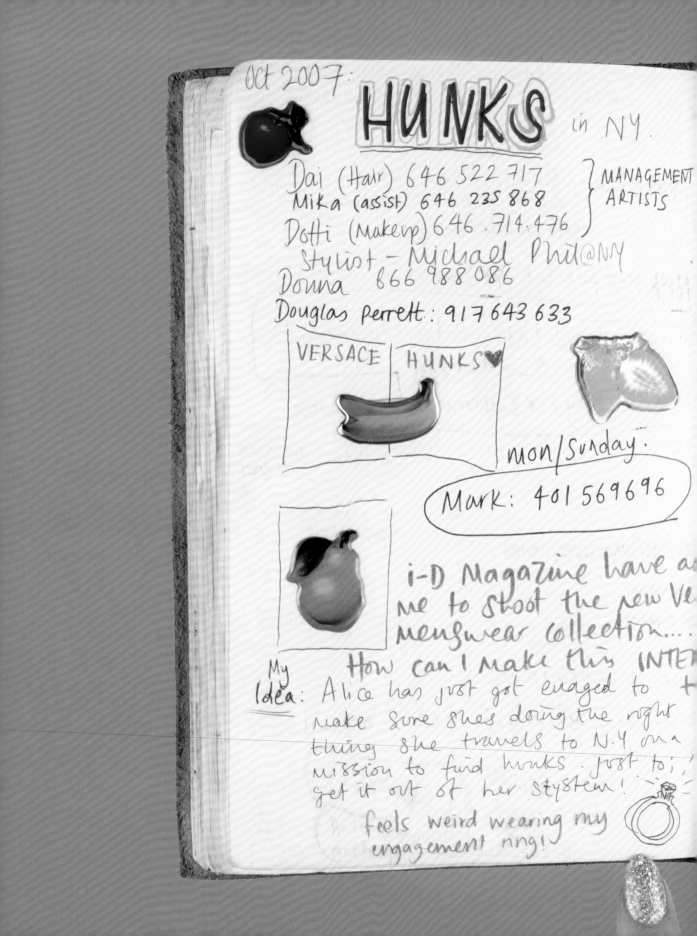

i-D Magazine have a[sked]
me to shoot the new Ve[rsace]
menswear collection....

My How can I make this INTE[R...]
Idea: Alice has just got engaged to t[...]
 make sure she's doing the right
 thing she travels to N.Y on a
 mission to find hunks. just to;
 get it out of her styf5tem!

 feels weird wearing my
 engagement ring!

VERSACE NEW COLLECTION:

Sat - = Tom
= Chance
= Orion
= Enrique

muscle guys Brooklyn

Sun - Mark
Tony in Brooklyn. (Tina + Tiny!)
- Michael Lucas

Mon - Will @ 1.30pm.

Type of men Im looking for:

Porno Star ♡
Fireman ♡ ♥
Supermodel ♡
Hunks ♡ ♥ ♡ ♡
Dancers -go go/LATIN
 A group
Body Builders ♡ ♡ ♡
Beautiful ♡ PREPPY ♡
 American

kisses ... Alice

kisses ... Alice

DREAM
LOVER ♡
COME RESUE
ME!

...TING FOR ME PERSONALLY ?????
Email/Call ~~Rich~~ Rich @ THE BOX club.
re. Sunday night.

WWW. most beautiful man. com
quite obsessed with this website4

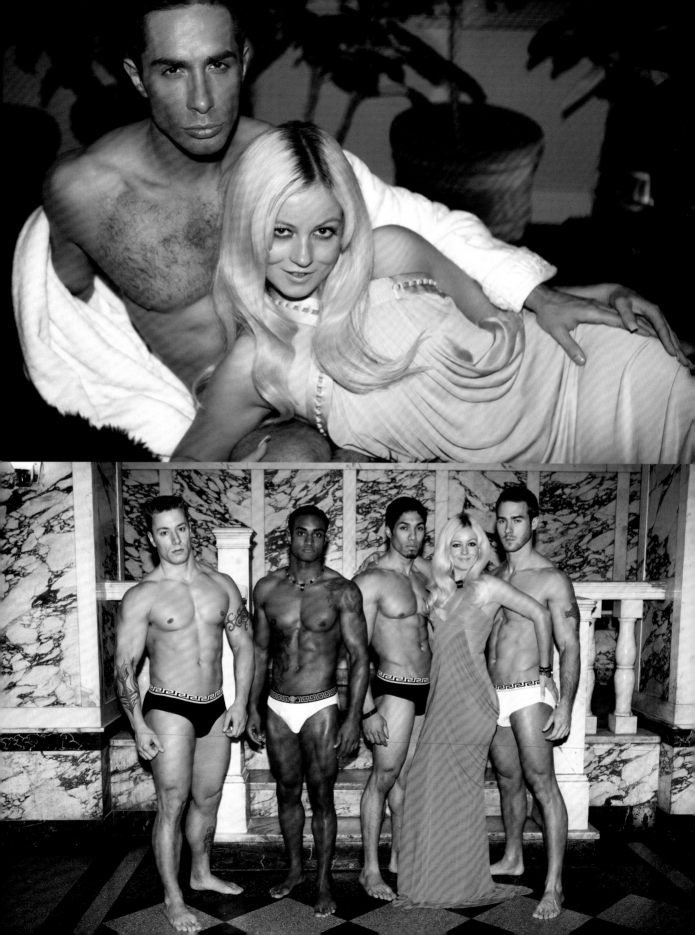

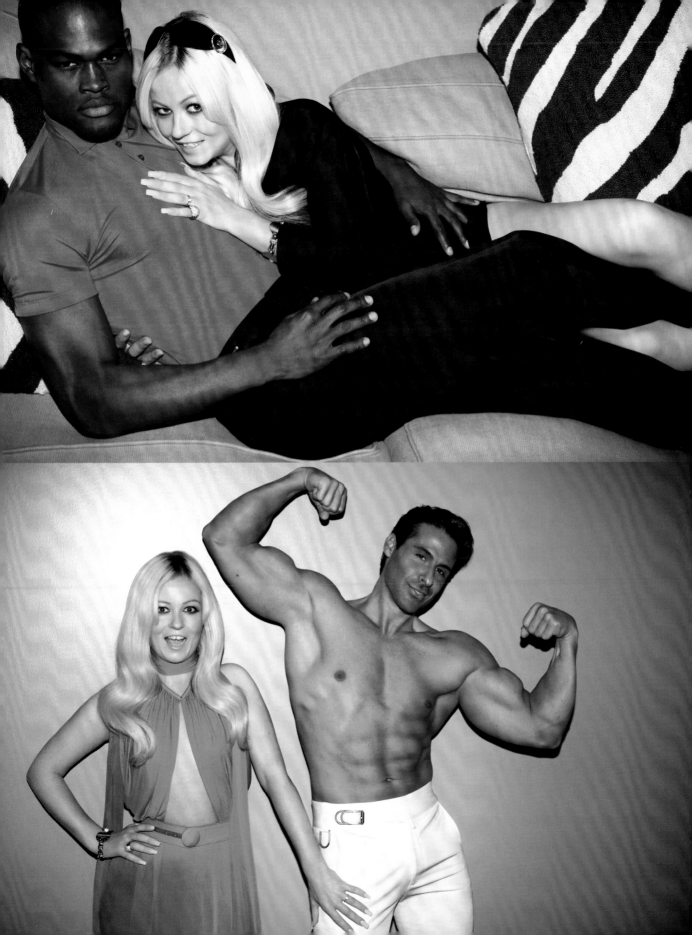

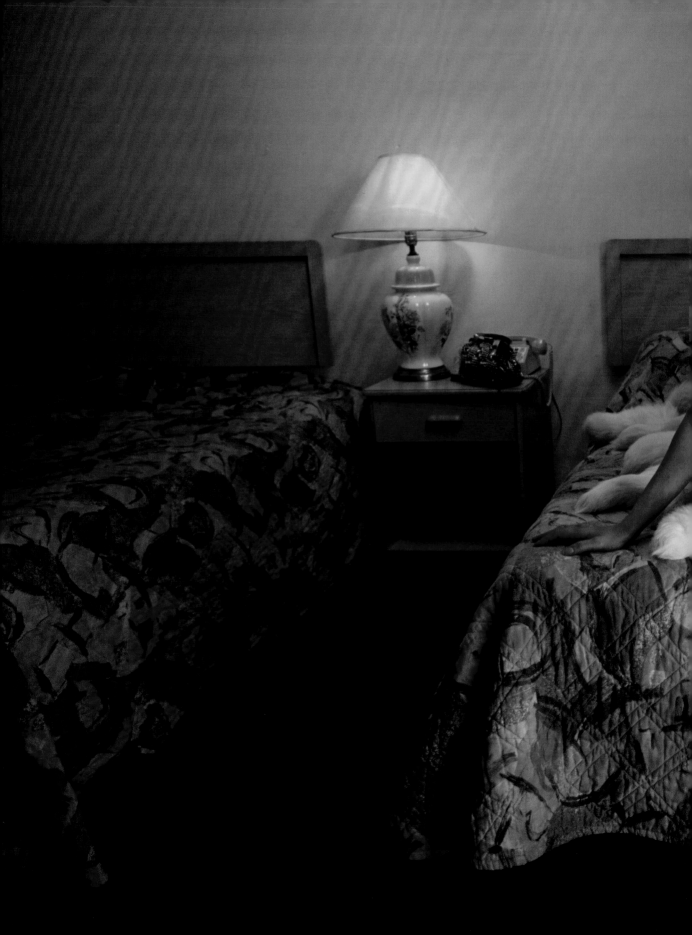

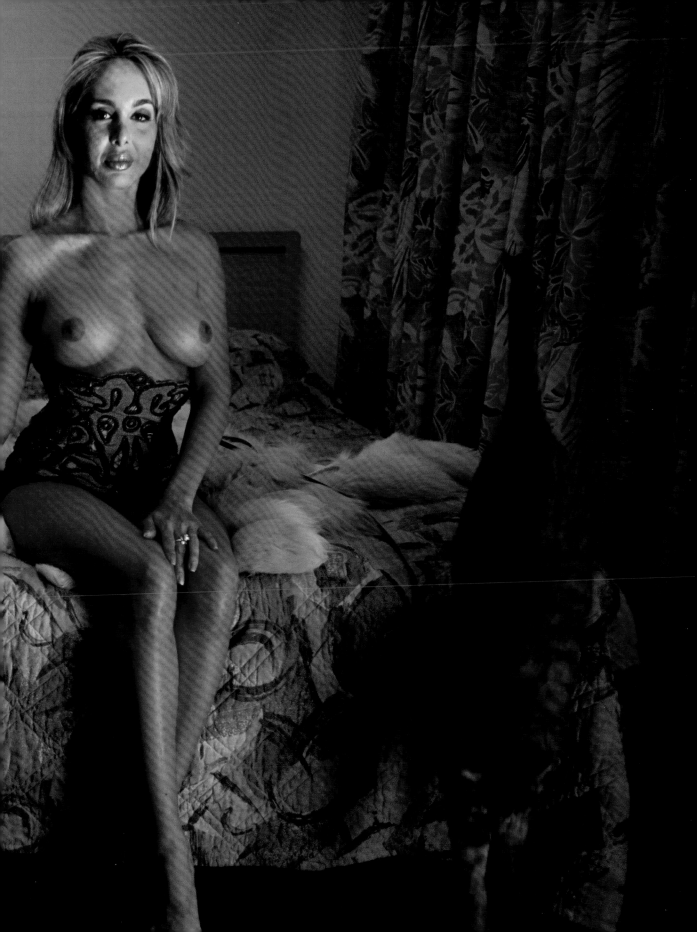

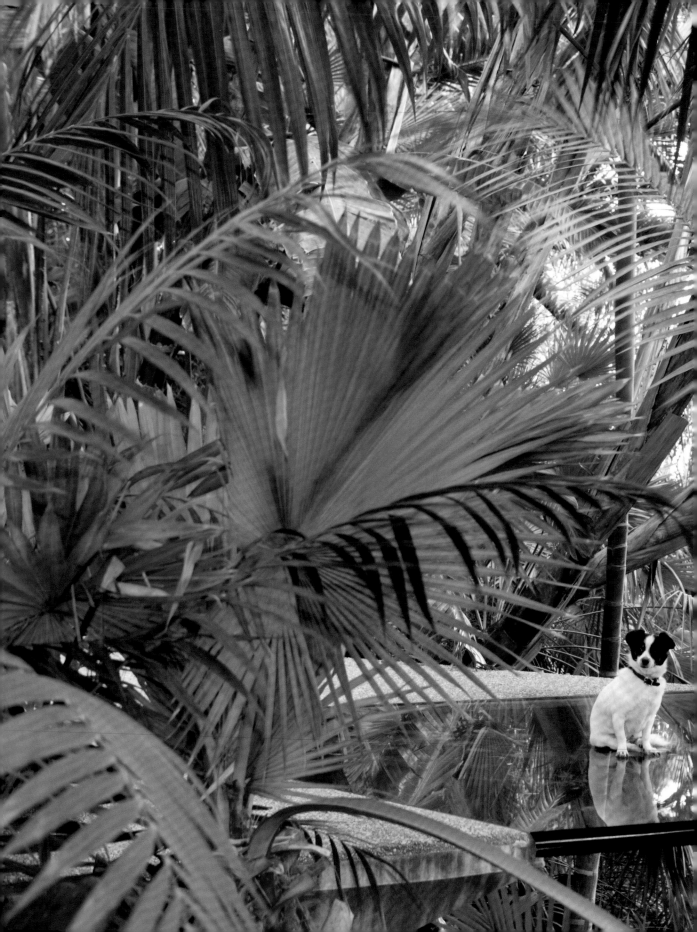

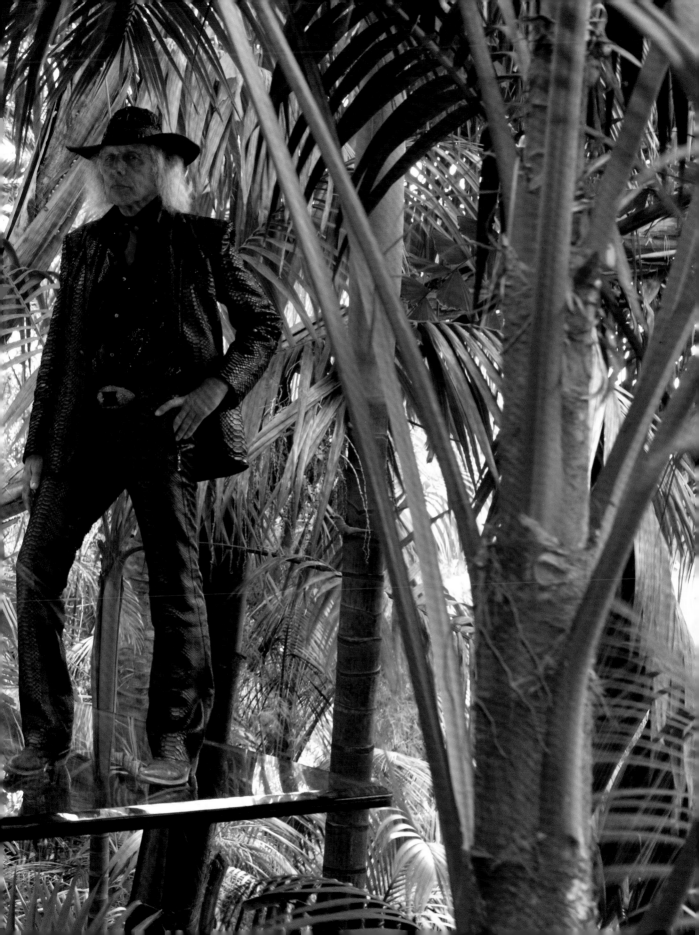

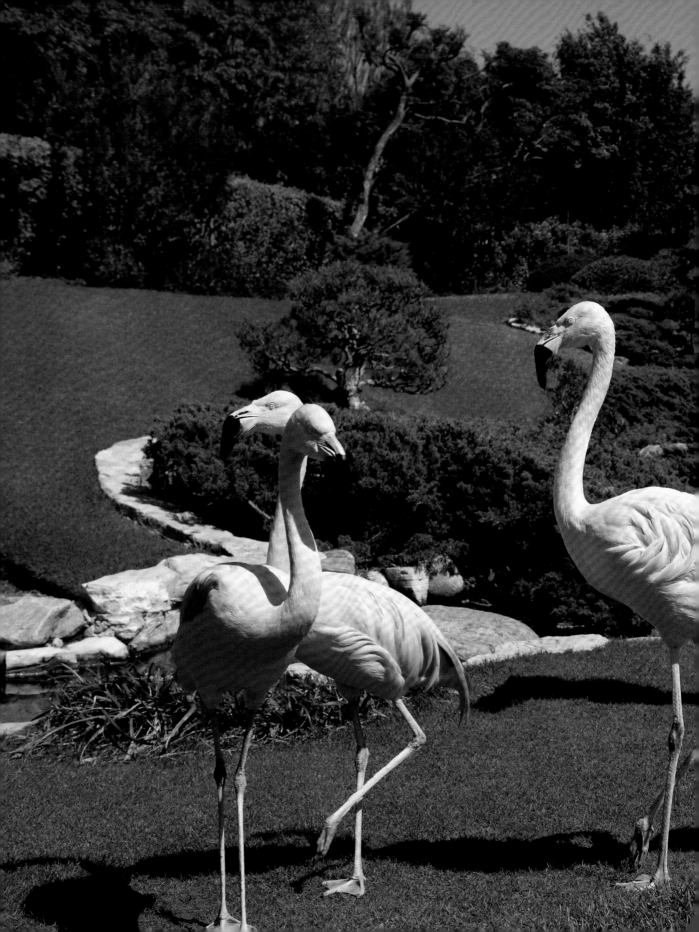

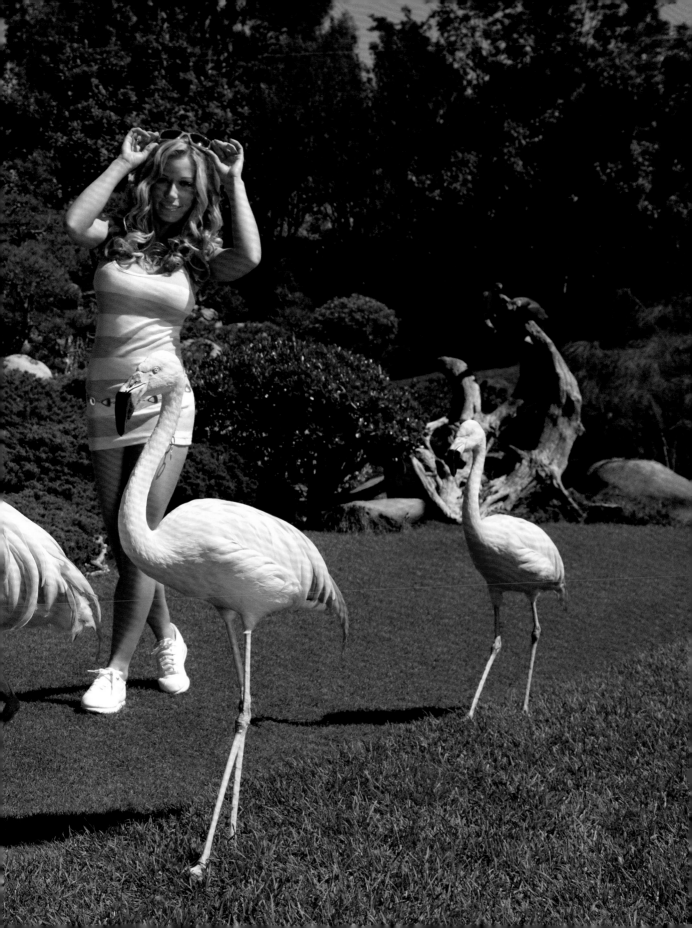

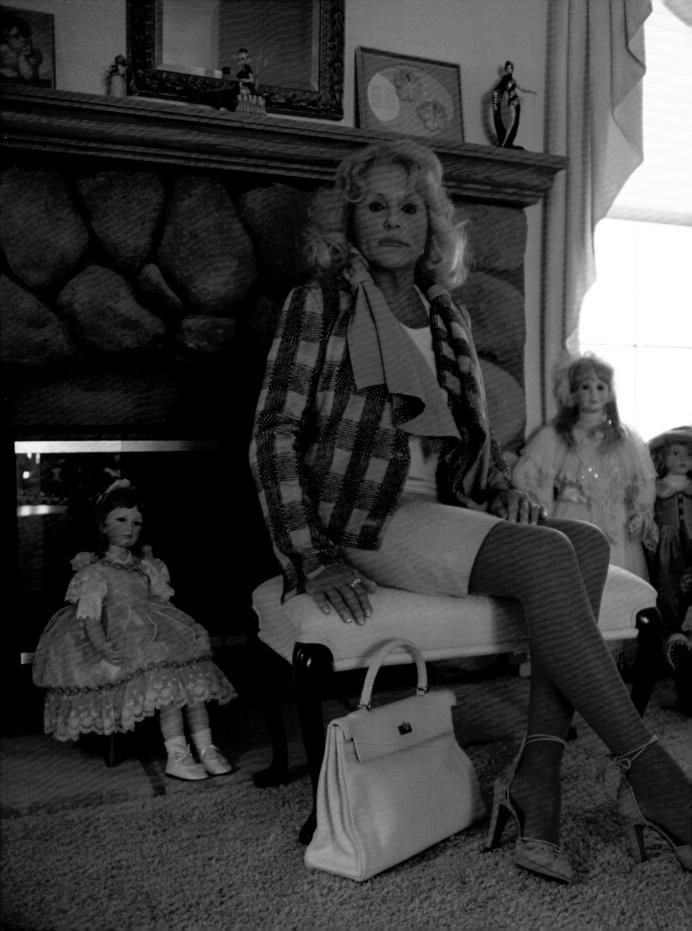

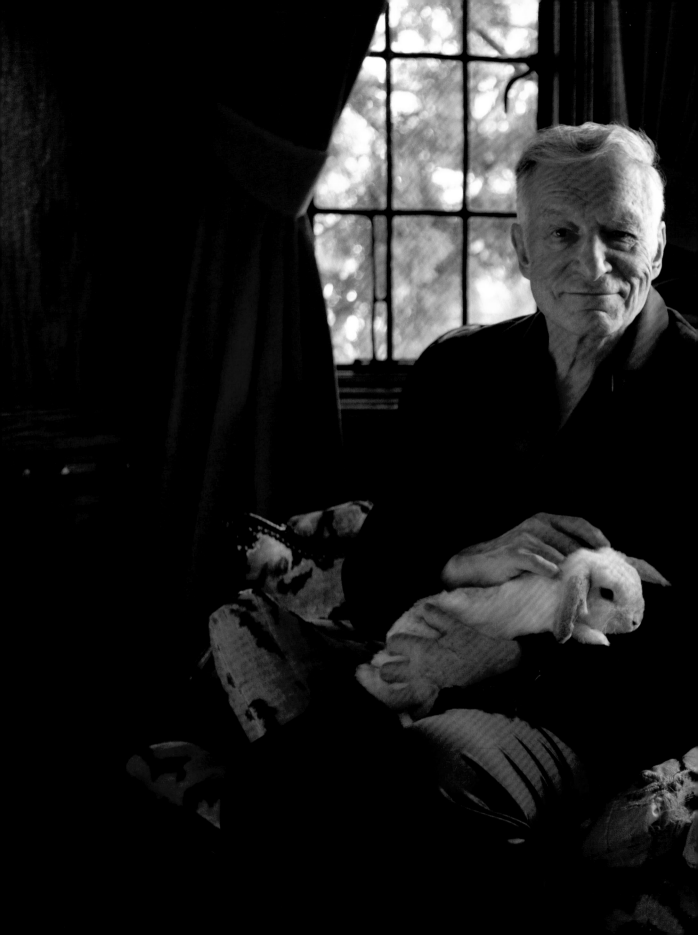

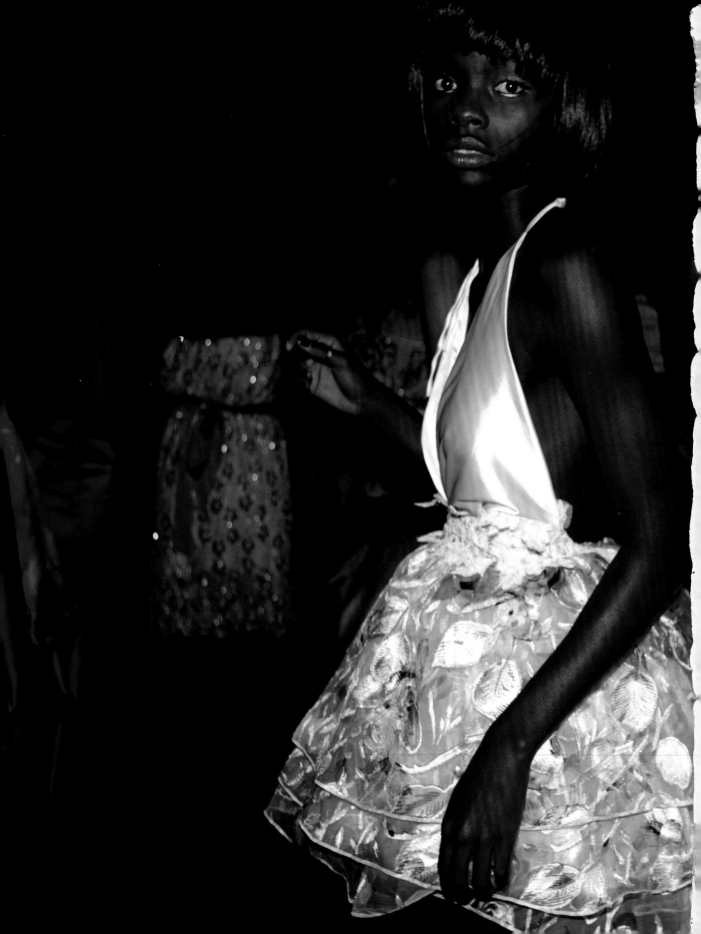

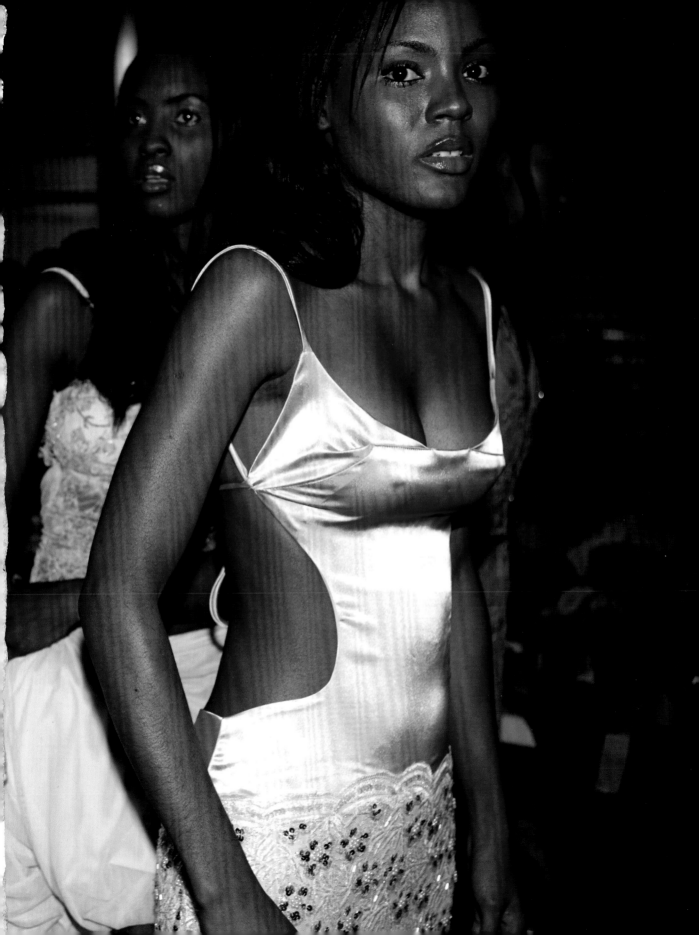

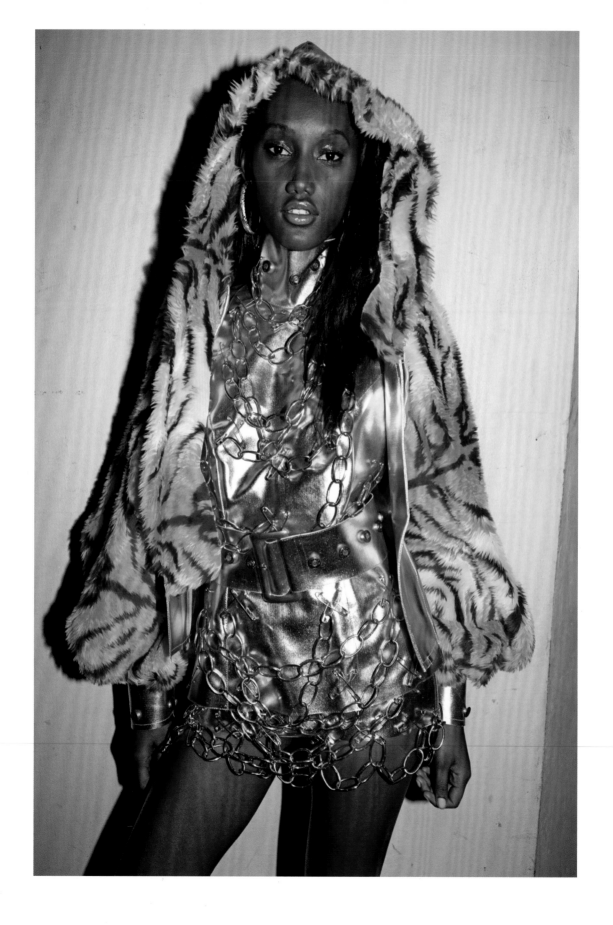

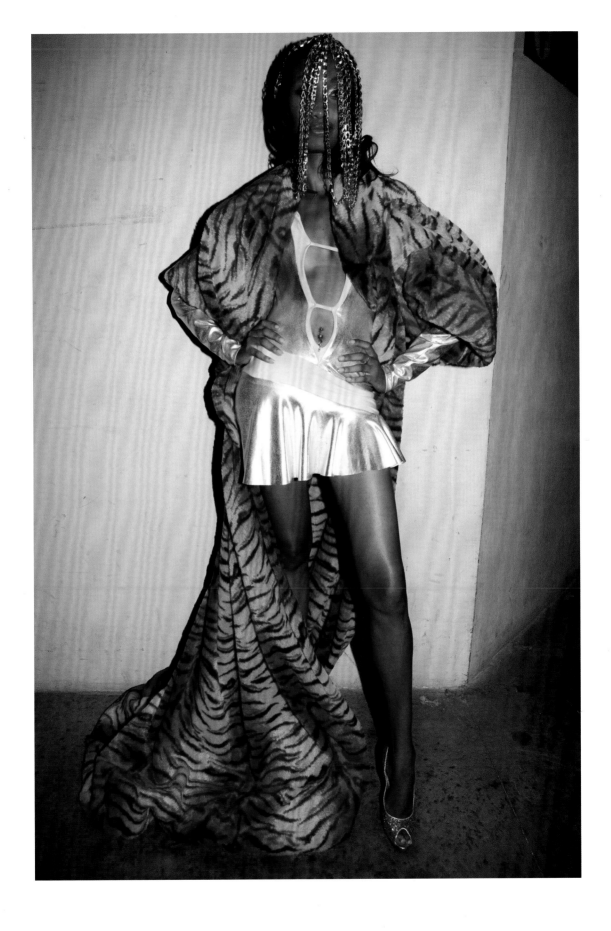

Jamaica June 2007: iD Magazine

✳ Kingston. Hilton. "Carribean Fashion Week":
staying at the ⬆ Me, Sam + Dave have come to Kingston Jar

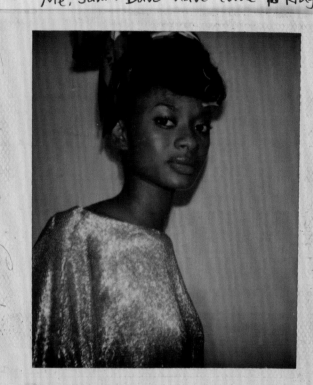

Sasheria - Ford

(1 - 23rd March)
✳ David Gill gallery SW2 11
bee

this beautiful girl had never seen a polariod b4.
She tried writing her name on the photo bit
at first. I don't know why but this really
interested me.

Cuba: 16th - 29th (uk 30th) October.
Air france: 21 hrs flying + 4 hrs stopover - leaves 9.15 . 17.35
Iberia: 23 hrs flying + 3 hours stopover - leaves 12pm . 8.40p

ja 0727401291

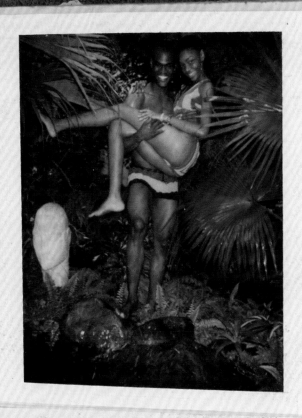

Oraine & posing in the Hotel grounds
for me

The blue post Pub

Kingsly St

Highlever Rd

London W10

Kingston College Basketball team.
Roan Burrowes under 14's.

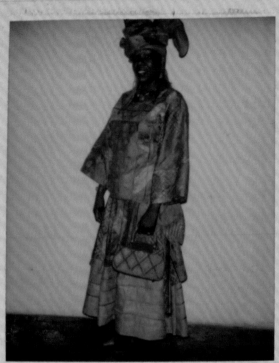

Donnette Cooper
jafrican@verizon.net

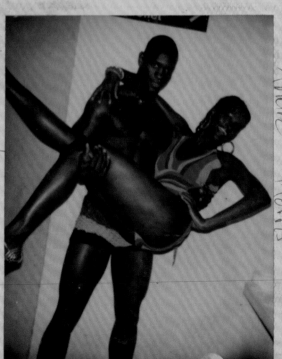

Andre Morris

Nadine Willis SMC
NY·Models yahoo.com

morrisandre80000@5mail.com

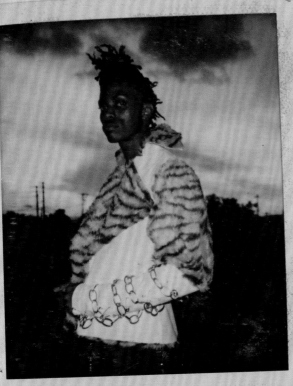

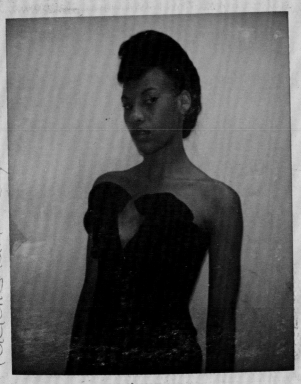

iD: demo: need to see layout / retouch. images / VIDEO TAPE to senie INTERN (@iD?)

* BIG PUSH GUIDE TO CHINA *

Antonio Lum burbatela
Posh Punk Couture @yaho-com

Aprons Bryton
Papychook @yahoo-com —clothing

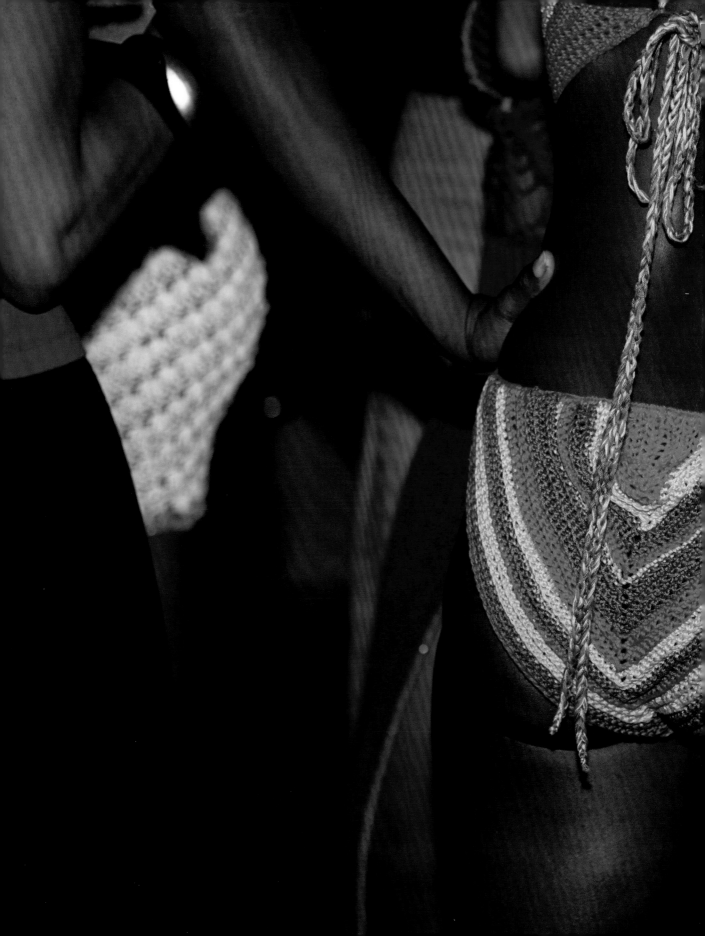

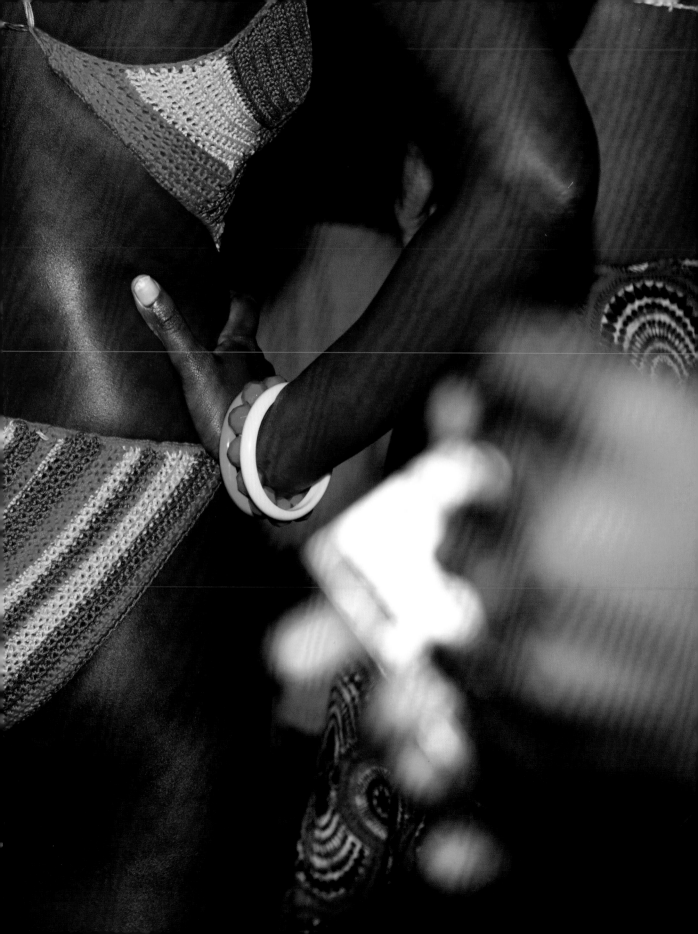

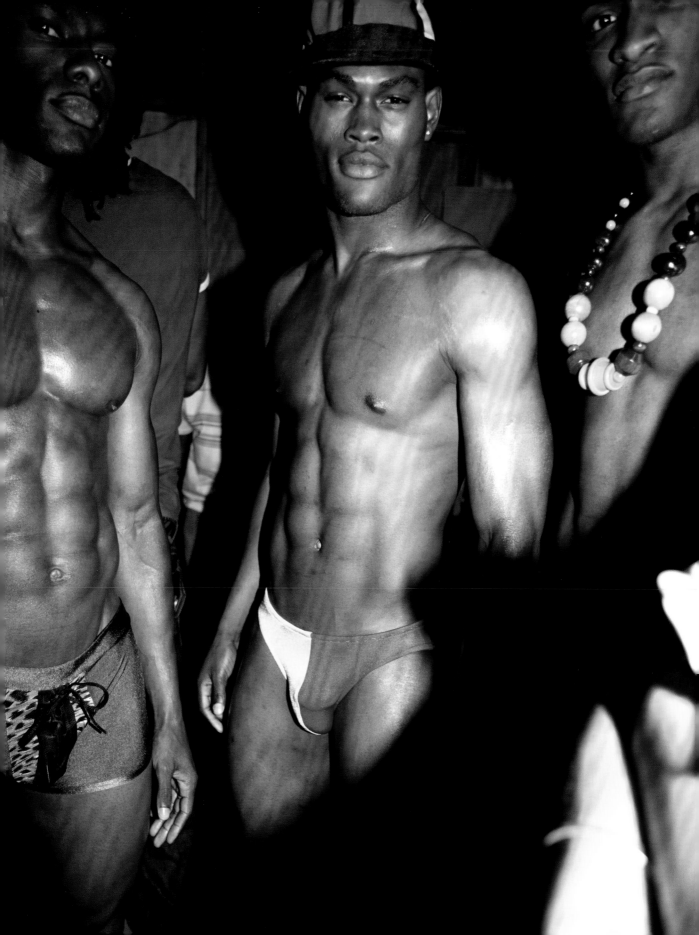

I first met Alice when she was introduced to me by the art director Lee Swillingham. He had seen her work and thought it could be interesting for *Pop* magazine, which we both worked on at the time.

I loved how effortless her pictures were – and still are. She had worked at Agent Provocateur and we had mutual friends. She had photographed some of the shop girls in their pink uniforms with their bras peeking out; one of them was Paloma Faith.

I decided to work with Alice in a super-loose way. I didn't see the point of being dictatorial in my commissioning. In fact, she set a template for how I would work with documentary photographers in the future (and how to hide the odd fashion label in there). I would send her and members of my fashion team off around the world – anywhere we liked the look of that season. Off they would go with trunks full of clothes, fly to a city (somewhere that was generally quite remote), rent a car and take a road trip for a few weeks. They would cast as they went along and shoot various characters, families and relationships.

The results were always monumental. Alice would come back with amazing character studies, generally of people holding handbags as it gave them an air of 'old style' portraiture (and made advertisers very happy).

My favourite images were the ones she did in Death Valley. There was something so special and magnificent about those pictures; she truly captured the essence of the people. I'd been there quite a few times and had fallen in love with the place – which is, according to Americans, always how the English feel about Death Valley.

Another favourite was the series of portraits of celebrities and their 'pets', featuring a young Dakota Johnson. The photographs show celebrities posing with exotic creatures (lions, snakes, etc.) as well as slightly more pedestrian pets such as dogs and horses.

Alice's photographs give an impression of abandonment. She makes it look so easy – and, having been on set with her quite a few times, it is pretty easy – but these shoots involve months of production and weeks of shooting (we would always have the fashion PRs calling to complain that 'look 34' had been and gone). It's Alice's character that really drives that ease once you get on set.

Katie Grand

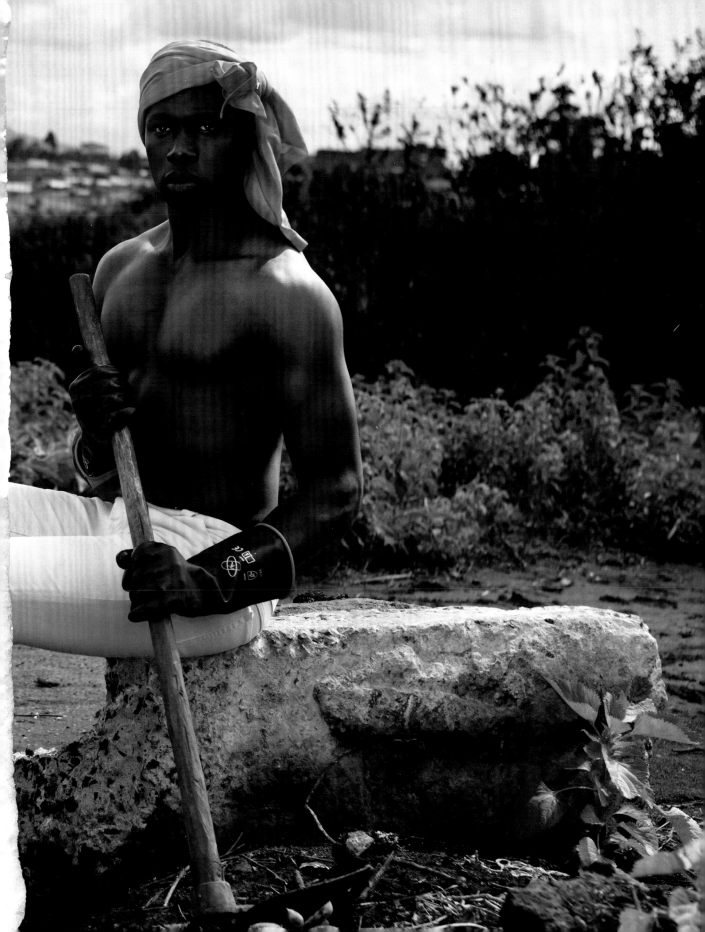

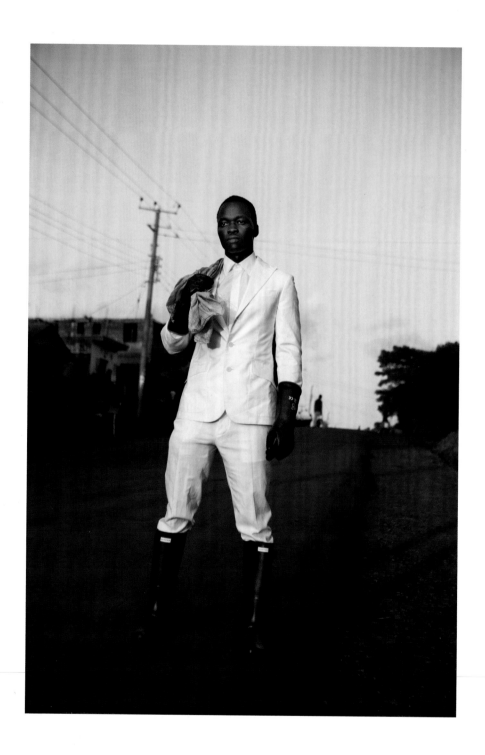

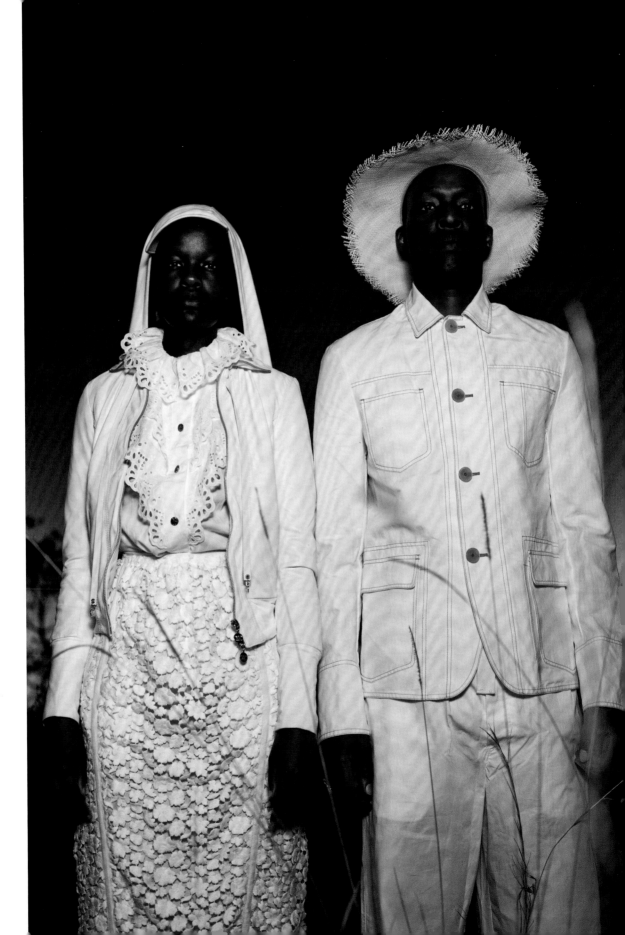

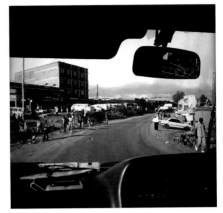

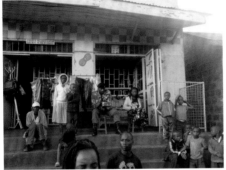
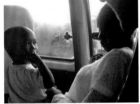
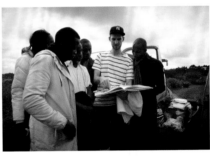

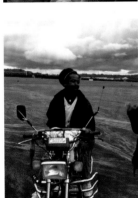

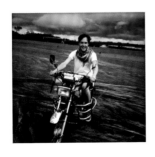
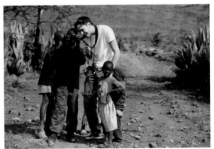

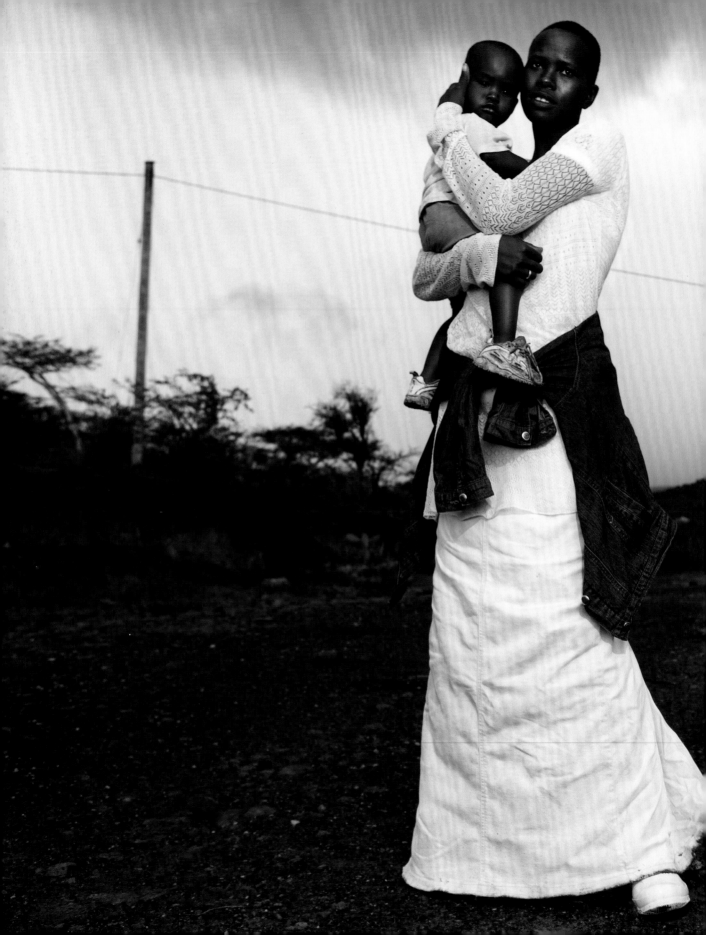

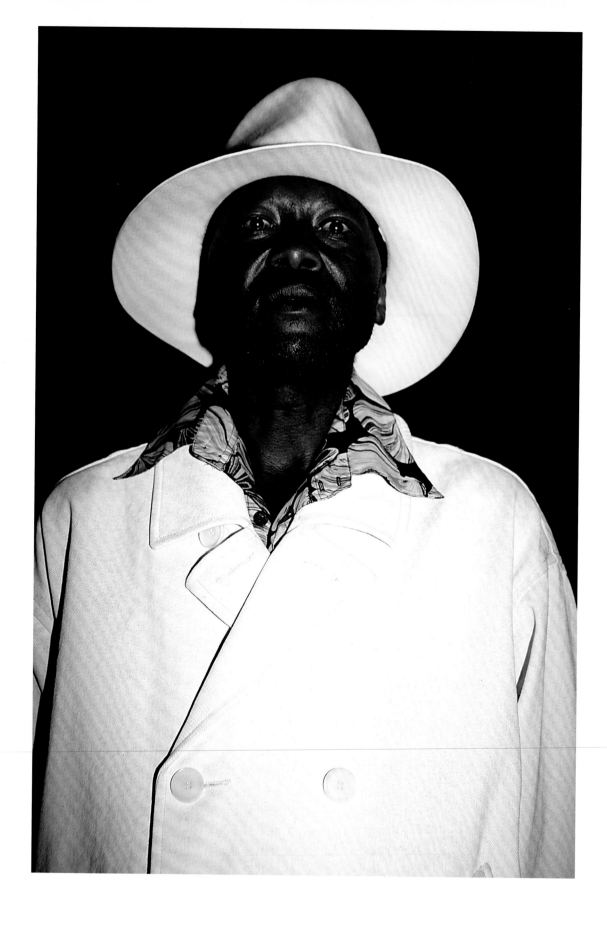

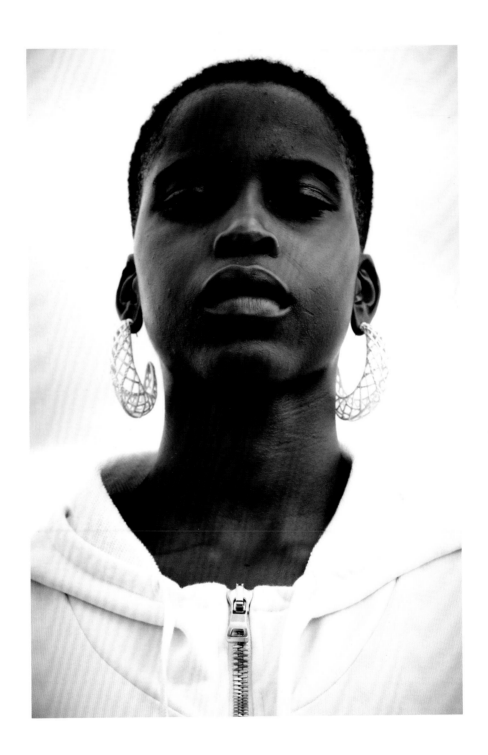

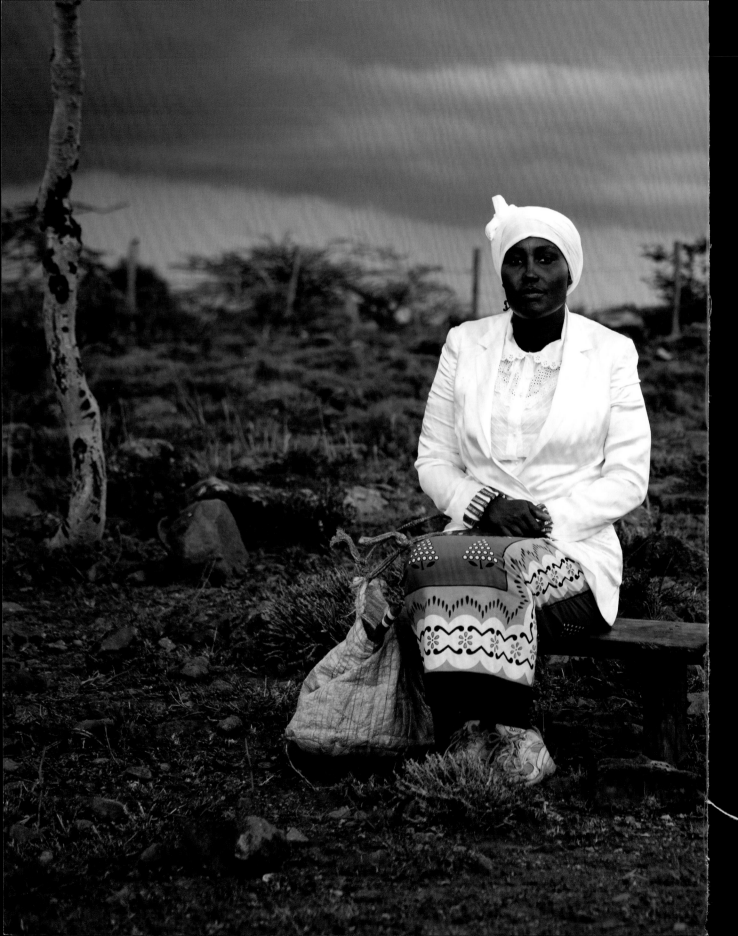

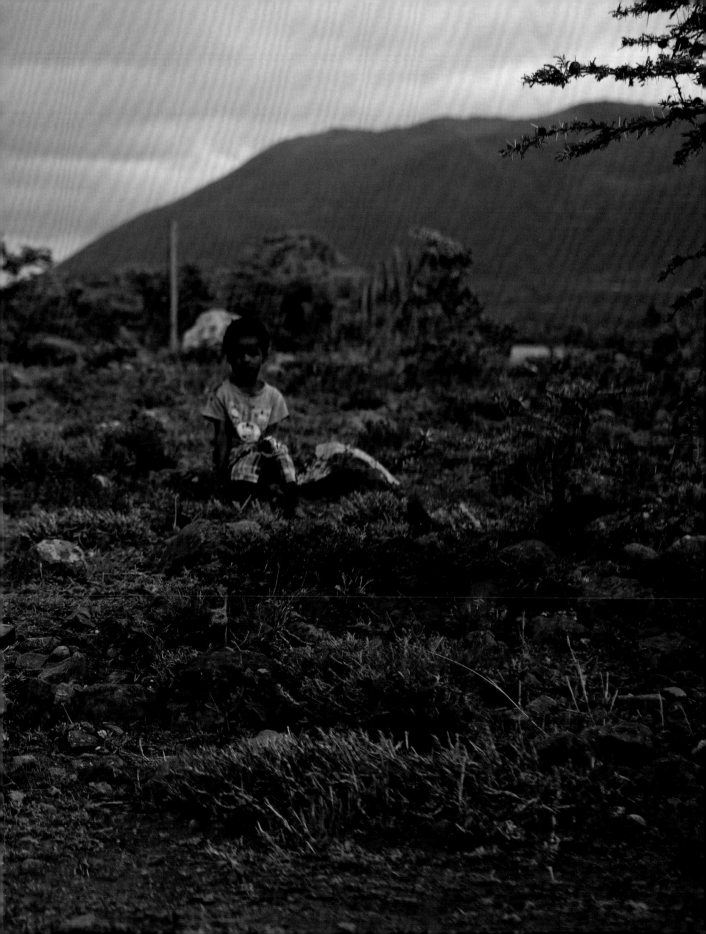

In 2015 I was one of the chairmen of the Nikon Photo Contest, held in Shanghai. The judging team was a global mix of accomplished photographers, curators, writers and museum directors from all branches of the medium. A seminar with an eager university audience provided a welcome break after a week behind closed doors looking at thousands of images and videos. The Q&A session was lively, and the students were both starstruck and curious about the accomplishments of the eclectic group of judges. There was suddenly a break in the dialogue when one very vocal male student exclaimed, 'You're only famous because you have access to the best cameras and equipment!'

Shocked, I tried to gather my thoughts. Looking down the line of talent assembled on stage, I saw the fresh face of London photographer Alice Hawkins, who inspired my response: 'Interesting people take interesting pictures.'

Alice Hawkins defies categorization despite being a star in the worlds of fashion advertising and editorial. She is a walking diary of a global life, going to new places with her camera both figuratively and literally. She is clearly a global citizen, yet her curiosity goes deeper than social voyeurism with Western bias: she engages completely with the places and people that she photographs.

What I enjoy most about Alice's work is that it is fundamentally different from the style of photography I produce for my Japanese company. I love that Alice and I are so different.

It would be easy to discount her work because of the high gloss that she regularly projects through her images. It would be easy to underestimate the boldness of her approach, to think that Alice depended primarily on the superficial. But therein lies the sophistication and intelligence of her approach. She treats her subjects with complete respect, without a hint of irony. Often she will prove her respect for her subjects by becoming one of them. The power of Alice as a creator lies in her honesty.

When I asked Alice about her approach to photographs in which she features alongside her subjects or becomes the subject herself, she explained: 'I am in my pictures in a spiritual and physical way. When doing these kinds of pictures, I am really living in the moment. The pictures are autobiographical.'

Alice recently became a mother, and I am certain this period will only heighten her ability to find the soul beneath all the fashion, wigs and make-up. She has a kind heart and an even kinder eye.

The growth of Alice Hawkins and her pictures is evident in this book, but her future will be even more personal, with an even greater grasp of humanity and all its quirks and imperfections. Alice's adventures have only just begun.

John C. Jay

Magazines

Citizen K, Esquire UK, Garage, Harper's Bazaar US, i-D, The Independent, Love, Ponystep, Pop, Stella (The Telegraph), Sunday Times Style, Russian Vogue

Fashion Stylists

Alexander Fury

Great Britain p. 26

Katie Grand

Italy pp. 108–9, 110–11; USA p. 154

Ian Luka

Great Britain pp. 34–35

Kimi O'Neill

Great Britain pp. 24, 27, 36–37, 38–39; USA pp. 134–35, 136–37, 138–39, 140–41, 142–43, 144–45, 147, 150–51, 152–53, 156–57, 164–65, 166–67, 168–69, 172–73

Michael Philouze

Great Britain pp. 20, 23; USA pp. 158–59, 160–61, 162–63

Charlotte Stockdale

Great Britain pp. 40–41, 42–43

Anders Sølvsten Thomsen

Great Britain pp. 32–33; Cuba (pp. 48–63); Hawaii (pp. 66–77); Nairobi (pp. 192–203)

Samantha Willoughby

Great Britain pp. 10–11, 12–13, 14–15, 16–17, 18–19, 28–29, 44–45; India (pp. 80–95); USA pp. 116–17, 118–19, 120–21, 122–23, 124–25, 126–27, 128–29, 131, 132–33, 146, 155, 170–71; Russia (pp. 206–17)

Hair Stylists

Eamonn Hughes

Great Britain pp. 10–11, 12–13, 14–15, 16–17, 18–19, 20, 23, 24, 32–33, 34–35, 36–37, 38–39, 40–41, 42–43; Hawaii (pp. 66–77); USA p. 155

Sami Knight

Great Britain p. 26

Koji Ichikawa

Great Britain pp. 24, 27

Richard Scorer

Great Britain pp. 44–45

Make-up Artists

Sharon Dowsett

Great Britain pp. 40–41, 42–43

Liz Martins

Great Britain pp. 16–17

Lan Nguyen-Grealis

Great Britain pp. 36–37, 38–39

Kirstin Piggott

Great Britain pp. 44–45

Clare Read

Great Britain pp. 26, 34–35

Gemma Smith-Edhouse

Great Britain pp. 10–11, 12–13, 14–15, 18, 20, 23; USA p. 155

Digital Artwork

Hempstead May; Notion London; Spring Post

Production

Daniele Comeaux, Hawaii; The Dot Factory Ltd, Manchester; Matrix Studios, London; Caroline Mbindyo, Nairobi; Patricia McMahon, London; Ragi Productions, India; Rosco Production, London; WeFolk, London

Assistants

Leoni-Blue Fleming, Rob Jarvis, David Lau, Phill Taylor

Nail Manicurists

Izabelle Bellamy

(sketchbook-page nails)

Marie Isabel

Great Britain pp. 36–37, 38–39

Trish Lomax

Great Britain pp. 44–45

Emma Zenter

Great Britain pp. 40–41, 42–43

to pose with a little white bunny on his lap. He sat down on the leopard-skin sofa in his favourite place in the mansion, the cinema room, and said to me with a look of shock, 'Oh wait, you're the photographer? You should be on the other side of the camera, honey.'

JAMAICA

The photographs in this chapter were shot for Caribbean Fashion Week, *i-D* magazine, Jamaica, 2007.

NAIROBI

The photographs in this chapter were shot for *Love* magazine, Nairobi, Kenya, 2011.

Nairobi is an unusual place, a sprawling city set against a backdrop of wildlife. Even the outskirts are hectic. You see many people walking to work along long rural roads, wearing clothes that you know once started off as a blouse on a granny in Yorkshire and now live another life in Nairobi.

RUSSIA

My experience of Russian people is that they are similar to a crème brûlée: once you crack the surface, you find that they're actually soft underneath. I started out wanting to photograph women who buy diamonds but ended up photographing a very diverse set of people in St Petersburg and Moscow. I loved how every millionaire came with their own bodyguard or chaperone, and how stern they all looked, especially the women – they're so tough, strong and powerful.

Death Valley is in the middle of nowhere. We drove around for hours without seeing a soul, and ended up casting in Walmart because everyone has to go there at some point. I felt like I'd gone to Mars. I'd never met anyone who believed in UFOs before, let alone had serious conversations about them. Death Valley opened my eyes to the other side of life, where wild horses run free and you can eat a burger in a brothel.

132–33

Sisters Angela Francisco and Barbi Mapes

'Life in Death Valley', *Pop* magazine
Death Valley, 2006

134–35

The Barbi Twins, Shane and Sia Barbi

Unpublished, 'Alice's American Safari',
Pop magazine
California, 2008

136–39

'Alice's American Safari'

(Sketchbook)

Pop magazine
California, 2008

140–41

Dashenka Giraldo with Victoria the Bengal Tiger

'Alice's American Safari', *Pop* magazine
Las Vegas, 2008

142–43

Tony Fercos with Sinbad the Lion

'Alice's American Safari', *Pop* magazine
Las Vegas, 2008

144–45

Shane Ayon with Spot, Sunny, Tikki and Picasso the Horse

'Alice's American Safari', *Pop* magazine
San Bernardino, 2008

146

Angie McGinnis

Unpublished, 'Somewhere in Texas',
Pop magazine
Carl's Corner, 2005

147

Gloria Winship

Unpublished, 'Alice's American Safari',
Pop magazine
San Bernardino, 2008

148–53

'Alice's American Safari'

(Sketchbook)

Pop magazine
California, 2008

154

Car park location (Left)

'Clothes to Fall in Love With', *Harper's Bazaar* US
New York, 2006

154

American jock (Right)

'Clothes to Fall in Love With', *Harper's Bazaar* US
New York, 2006

155

Gisele and Vida

Pop magazine
New York, 2005

156–57

Donny Edwards and Leila the Pomeranian

'Alice's American Safari', *Pop* magazine
Las Vegas, 2008

158–61

'Versace Hunks' (Sketchbook)

i-D magazine
New York, 2007

162

Michael Lucas and me (Above)

'Versace Hunks', *i-D* magazine
New York, 2007

162

Bodybuilders and me (Below)

'Versace Hunks', *i-D* magazine
New York, 2007

163

Oraine Barrett and me (Above)

'Versace Hunks', *i-D* magazine
New York, 2007

163

Anthony Catanzaro and me (Below)

'Versace Hunks', *i-D* magazine
New York, 2007

164–65

Eliset Lobato

Unpublished, 'Alice's American Safari',
Pop magazine
Fun City Motel, Las Vegas, 2008

166–67

James Goldstein

'Alice's American Safari', *Pop* magazine
Beverly Hills, 2008

168–69

Kendra Wilkinson

'Alice's American Safari', *Pop* magazine
Playboy Mansion, Beverly Hills, 2008
I was so excited that I couldn't stop filming as we drove to the Playboy Mansion. We felt like kids on the best school trip ever! Our dreams came true when we arrived and were given the tour by a lovely lady called Teri (Hef's publicist who has been working with him from the beginning). The three 'Girls of the Playboy Mansion' – Kendra, Holly and Bridget – kindly welcomed us, introduced us to their dogs, invited us into their bedrooms, and gushed over the clothes that Kimi, the stylist, had brought for them to wear.

170–71

Louise McInnis

'Life in Death Valley', *Pop* magazine
Death Valley, 2006

172–73

Hugh Hefner and Bunny

'Alice's American Safari', *Pop* magazine
Playboy Mansion, Beverly Hills, 2008
We didn't meet Hugh Hefner until it was time to photograph him. He agreed to wear the luxurious deep purple bathrobe and matching slippers Kimi had brought for him, and was happy

HAWAII

The photographs in this chapter were shot for 'Hawaii', *Love* magazine, 2013.

I fell in love with Hawaii a few years ago when I was on my honeymoon. It's a hyperreal tropical paradise. I decided that one day I would have to go back there and shoot. The opportunity came when Katie Grand asked me to shoot for a special issue of *Love* magazine; I asked her if I could do it in Hawaii and, to my surprise, she agreed.

The underwater swimming picture is one of the hardest photographs I've ever attempted. Magdalena had never swum in the sea before, and I'm not exactly a dab hand at underwater swimming and taking photographs at the same time. But we pushed ourselves to the maximum (with the expertise of two perfect local surfers, who kept us safe), and in the end I think we got something quite extraordinary. Magdalena managed to emerge from the sea like Ursula Andress in that James Bond film, and I just looked like a drowned rat.

INDIA

The photographs in this chapter were shot for 'Alice in India', *Pop* magazine, 2007.

India is a cinematic dream, bathed in glorious saturated colours. Crumbling colonial houses with peeling salmon-pink paint lie in timeless landscapes of palm trees and lush green vegetation. The people there are beautiful. But it's also a harsh place; the extreme divide between rich and poor turned my stomach, and I found myself photographing mainly the poor. It was difficult to street-cast there and find female subjects willing to pose for me, as they had to seek permission from someone else first – their mother-in-law or husband. I remember having a little cry once or twice, which I don't think has ever happened before.

When the pictures were published in *Pop* magazine, Katie Grand told me that Miuccia Prada had called her personally to congratulate me on the pictures and had asked Katie to pass on her compliments. That cheered me up!

I haven't seen him for years; I did hear a rumour that he'd left the country and is now living in Spain, or somewhere like that.

32
Abbey Clancy (Above)

'The Liver Birds', *Love* magazine
Liverpool, 2012

32
Edie Campbell (Below)

'The Liver Birds', *Love* magazine
Liverpool, 2012

33
Charlie Cowcher

'The Liver Birds', *Love* magazine
Liverpool, 2012

34–35
Margi Clarke

'The Queen of Liverpool', *Ponystep* magazine
Liverpool, 2013

36–37
Paloma Faith with the Fleming family

'Another Life', *Ponystep* magazine
Southampton, 2014

38–39
Paloma Faith with the Fleming family

'Another Life', *Ponystep* magazine
Southampton, 2014

For this project I didn't want to photograph Paloma as 'Paloma Faith'; I wanted to turn things upside down, for her to portray a completely different person from somewhere else, living another life. My assistant is from Southampton, and I asked her family there to let Paloma become part of them. Paloma is an incredible actress and shares my appreciation of British gritty films. This project is partly a homage to the films we love.

40
Lara Livings and Eloise Perry

'Essex Girls and Teddy Bears', *Garage* magazine
Essex, 2015

41
Paige Bunyan

'Essex Girls and Teddy Bears', *Garage* magazine
Essex, 2015

I've always wanted to photograph my friend's young teenage daughters, Paige and Scarlett. When Charlotte Stockdale asked me to shoot a story using humungous teddy bears, I thought this might be the perfect opportunity to finally photograph them and put them in a magazine. The girls and their mum helped gather their friends for me to cast, and I found other girls through friends and Facebook. I particularly love Essex girls; they are so glamorous and ballsy – what's not to love about that?

42
Sydney Loxdale

'Essex Girls and Teddy Bears', *Garage* magazine
Essex, 2015

43
Leonie Wall (Above)

'Essex Girls and Teddy Bears', *Garage* magazine
Essex, 2015

43
Codie Gates (Below)

'Essex Girls and Teddy Bears', *Garage* magazine
Essex, 2015

44–45
Gemma Collins

Ponystep magazine
Essex, 2012

The magazine asked me to shoot a different girl from the TV show *The Only Way Is Essex* but I preferred Gemma, so we photographed her instead at her childhood home in Romford. Gemma was everything I was hoping for and more. She reminds me of Jayne Mansfield. Her mum was there, making us sandwiches; her actual name is Joan Collins – genius!

CUBA

The photographs in this chapter were shot for 'Another Country', *Love* magazine, 2012.

Cuba is a complex, magical place. When you're there, it feels almost like you've left Planet Earth. This particular trip was really hard. I literally burst a blood vessel in Havana and ended up in hospital. It's a long story! We just didn't stop, we hardly slept, Anders (the stylist) had his laptop stolen, the humidity was stifling, most of the time I wanted to kill my local producer...but the mojitos tasted so good. You cannot help but be inspired in Cuba, bombarded with visions of wonder wherever you turn. There's something about the place and the people that enlightens me and fuels my imagination; it's like an old fairy tale that I'll forever be drawn back into.

48–49
Twins Adrianne and Alejandro Sanchez Estopinian

50
Adrianne and Alejandro Sanchez Estopinian (Above)

50
Joandy and Leysie (Below)

51
Lidiesky and her son Ricardo Gunzalez

Unpublished

52–53
Haila Valera Nauarro

54
Elizabeth Oramas Iglesias

55
Elizabeth Oramas Iglesias (Left)

55
Dailyn Duarte Aguilar (Right)

56–57
Yaima Pardo

GREAT BRITAIN

As much as I think it's important to discover and photograph new places and people around the world, I feel the undeniable pull of my homeland – a desire to see what's around me in my own backyard and pay homage to it.

10–13
'Portraits of a Well-mannered Generation' (Sketchbook)

Pop magazine
UK, 2005

14
Flynn Roddam

'Portraits of a Well-mannered Generation', *Pop* magazine
London, 2005

When I got to the house in west London to photograph three teenage girls, I was initially intrigued by their names; 'Tiger' stood out. I was also blown away when I discovered that the dad in the kitchen was the prolific artist Marc Quinn. I had wondered why there were so many famous pieces of art displayed on the walls.

15
Daisy Davies

'Portraits of a Well-mannered Generation', *Pop* magazine
London, 2005

I went to boarding school, and I've always wanted to go back and photograph the kids there. It's a lot posher and more expensive than when I was there, and I thought that once Daisy put on the Armani outfit, she looked like she could have been a member of the royal family.

16–17
Alysha Smith

Miss East Anglia, *Citizen K* magazine
Essex, 2006

A lady called Pam, whom I met through a fireman friend in Essex, introduced me to the world of regional beauty pageants. Because I'm a photographer, she asked if I'd like to be on the judging panel of the 'Miss East Anglia' beauty pageant. It was quite a mesmerizing experience. I decided that if I could, I'd like to make all the contestants' dreams come true, and style and photograph them for a fashion magazine. Over the years Pam has become my Essex girl link for casting, and she is such a one-off character herself.

18
JJ

'Essex Girls and Handbags', *i-D* magazine
Essex, 2005

19
Jade Cartwright

'Essex Girls and Handbags', *i-D* magazine
Essex, 2005

20
Sarah Chambers

'D&G Glamour Girls', *i-D* magazine
London, 2007

My fascination with Page 3 girls started when I was young. A neighbour and I would go through his collection of Page 3 cut-outs and organize them by our favourite girls on his bedroom floor. When *i-D* magazine asked me to photograph the new D&G collection – some of the most glamorous dresses I'd ever seen – I knew I wanted glamorous Page 3 girls to wear them.

21
Amanda

Unpublished personal work
Essex, 2005

Amanda and I worked together at the Warren Wood pub as barmaids when I was in my late teens/early twenties. She is so glamorous, even her voice sparkles. She is pictured here in her back garden.

22
Peter Stringfellow and me

'An Evening with Mr Peter Stringfellow', *Sunday Times Style*
London, 2007

23
Lisa Marie

'D&G Glamour Girls', *i-D* magazine
London, 2007

Glorious Scottish model Lisa Marie, posing at a friend's pink flat in Islington.

24
Sarah Ferguson (Left)

Duchess of York, *Stella* magazine (*The Telegraph*)
London, 2009

24
Kimi O'Neill and me (Right)

D&G self-portrait (HRH The Queen and the Princess Royal), *Pop* magazine
London, 2008

25
Queenie

Chingford Ladies' Tea Dance Club, unpublished personal work
Essex, 2005

26
Kate

Duchess of Cambridge lookalike Gabriella Munro Douglas, *The Independent Magazine*
London, 2013

27
Kimi O'Neill and me

D&G self-portrait (HRH The Queen and the Princess Royal), *Pop* magazine
London, 2008

28–29
Charlie Driver

'Portraits of a Well-mannered Generation', *Pop* magazine
London, 2005

30–31
Johnny Boy

Unpublished personal work
Essex, 2004

Johnny Boy was a regular at the Warren Wood pub, where I worked as a barmaid. He was a larger-than-life character and I adored him. He lived in a big house in Epping Forest, and one day he let me photograph him there. He was quite an exhibitionist and made it so easy.

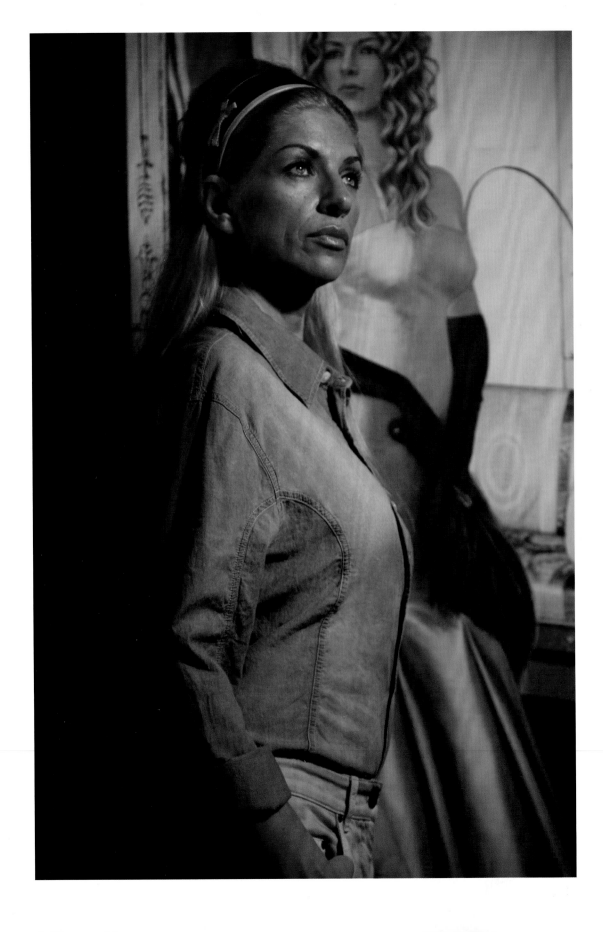

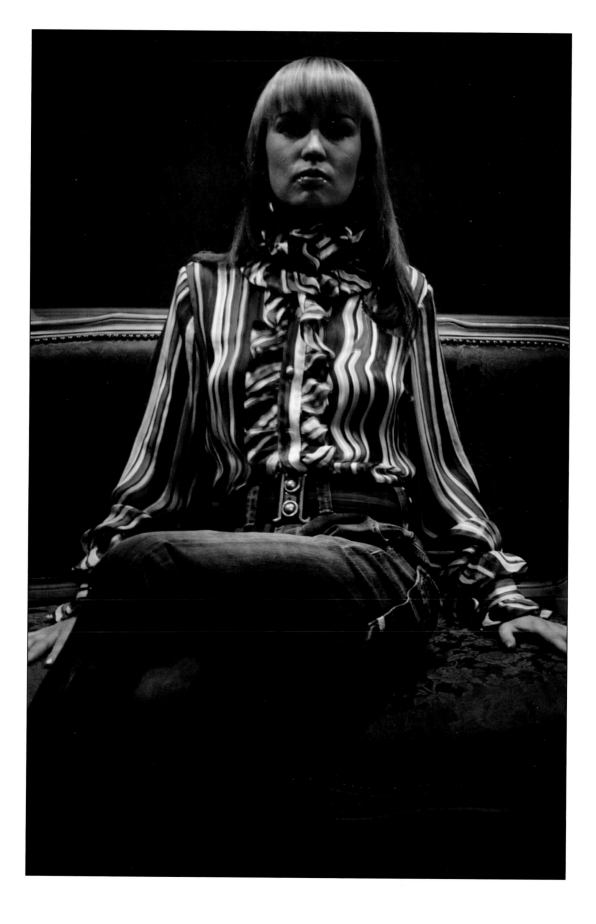

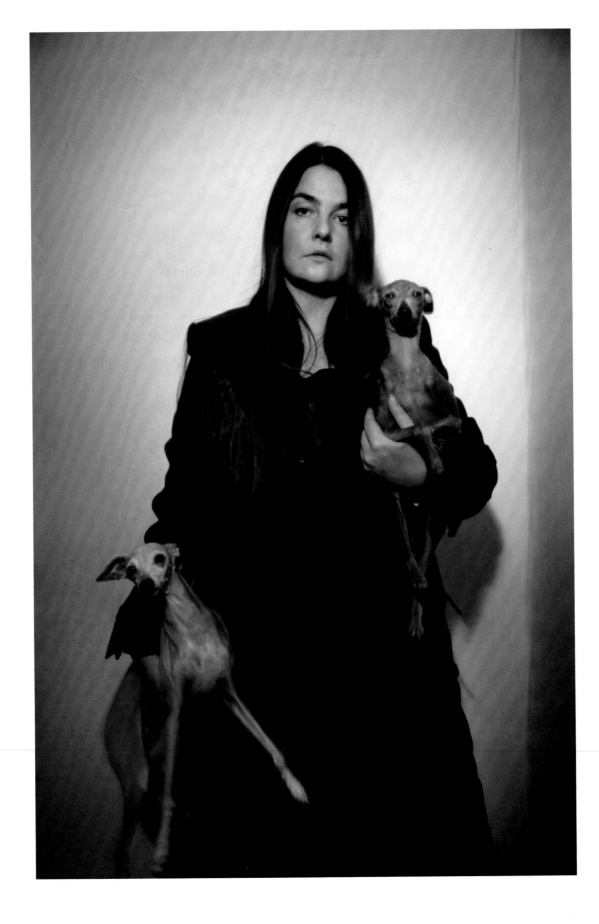

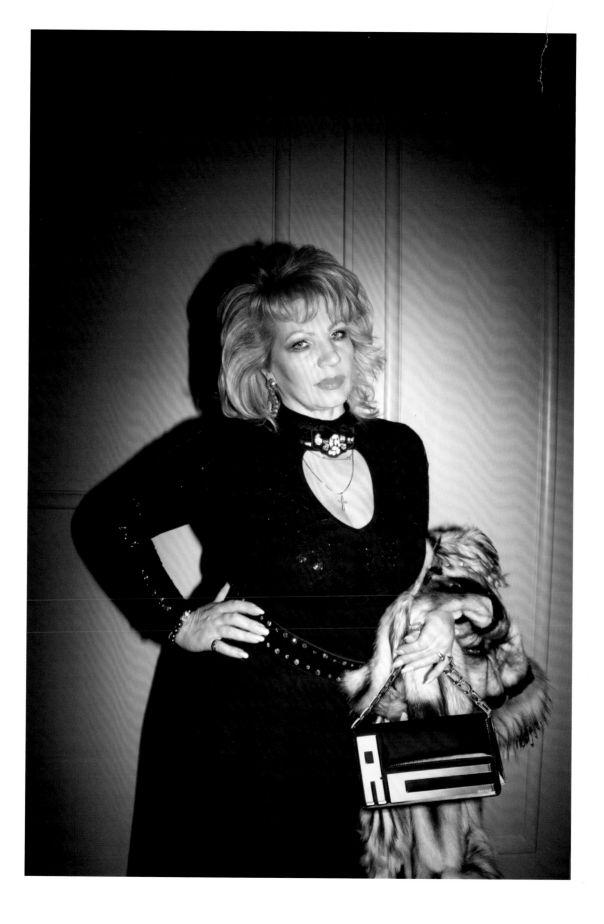

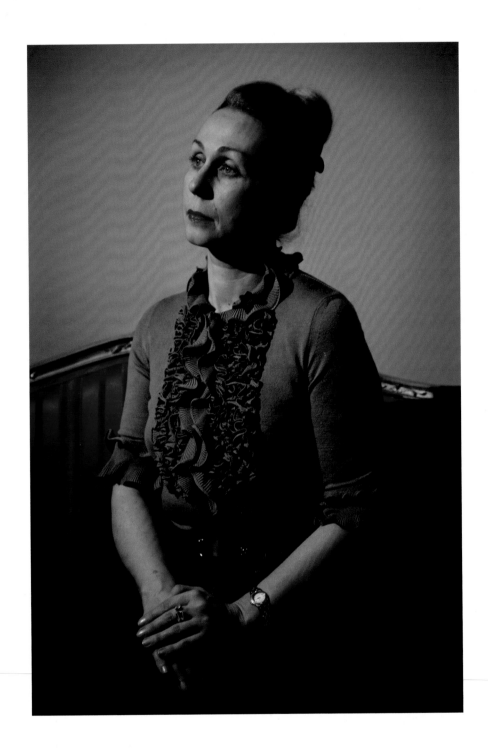

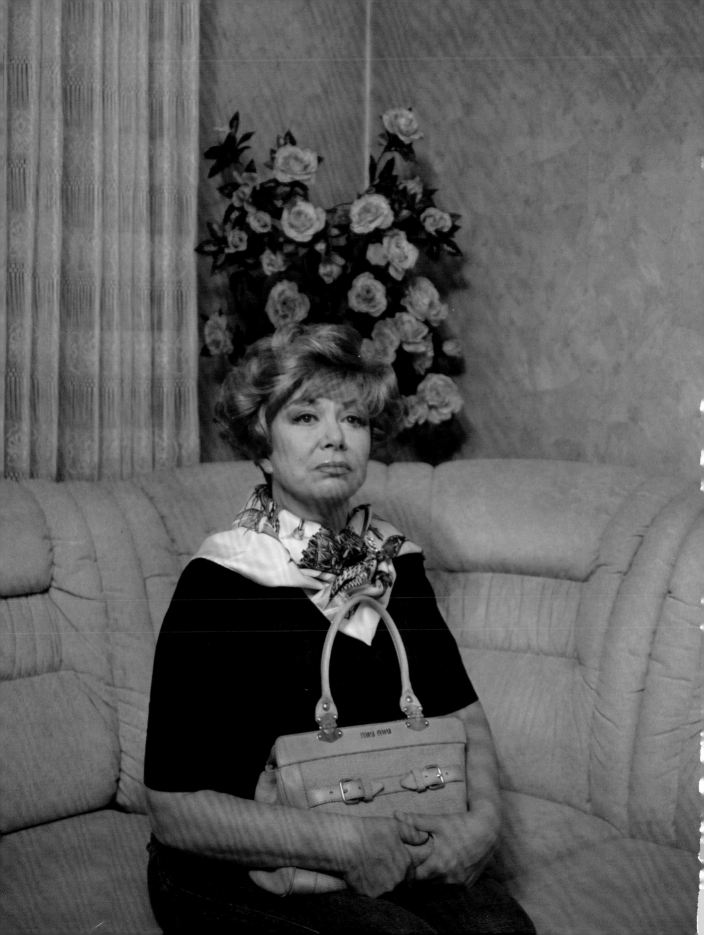

PICTURES FROM HURRELLS BOOK:

REF PICS:

PARTY?
PARTY?

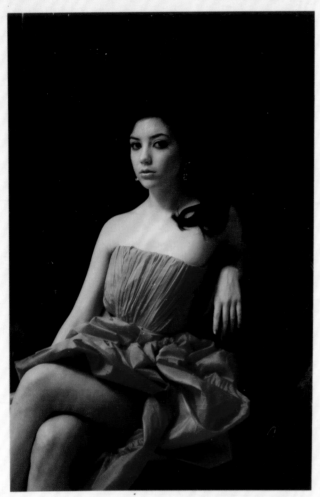

TAKE TO LAS VEGAS FOR
INDEPENDENT SHOOT/COVER:
- CAMERA 1DS MARK II
- LAPTOP + CHARGERS.
- MONOPOD....

- SORT OUTFIT FOR PARTY!

deadline for
Independent → 21st Nov.

Vi. WESTWOOD
BLACK DRESS
/RED STRIPY?

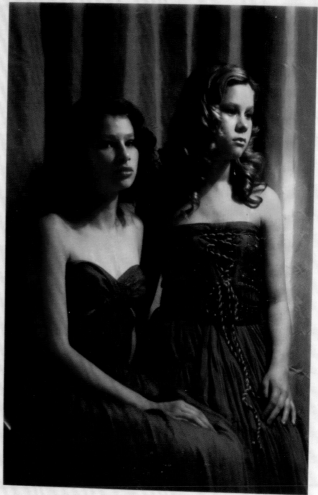

Just used a lamp for these.
TRI POD - MONO-POD.
REFLECTOR - LASTOLITE } ? BUY FOR RUSSIA TRIP.

TWO RED HEADS + STANDS - Spring — Dave @
 ligh
 — SLR - ask/give
 — RUSSIA - ask Valen
Miss St. Petersburg.... to get qu
Miss Russia email

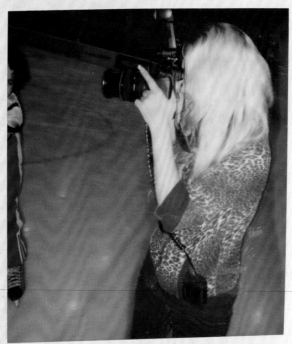

Moscow
Russia
006

...ria
production)

Me shooting in Moscow. Generation V.
dec 200¾6 Russian Vogue.

MOSCOW
RUSSIA
DEC006'
RUSSIAN

VOGUE.

Actress
lady
in
films.